Riopelle

In Conversation

Riopelle

In Conversation

GILBERT ÉROUART

With an Interview by Fernand Seguin

Translated by Donald Winkler

Original title: Entretiens avec Jean-Paul Riopelle
Copyright © 1993, Éditions Liber
English translation copyright © 1995, House of Anansi Press Limited

Published under agreement with
Éditions Liber, Montreal

English translation published in 1995 by
House of Anansi Press Limited
1800 Steeles Avenue West
Concord, Ontario L4K 2P3
Tel. (416) 445-3333
Fax (416) 445-5967

Canadian Cataloguing in Publication Data

Riopelle, Jean-Paul, 1923-
Riopelle in conversation

Translation of: Entretiens avec Jean-Paul Riopelle.
ISBN 0-88784-563-0

1. Riopelle, Jean-Paul, 1923- - Interviews.
2. Painters - Quebec (Province) - Interviews.
I. Érouart, Gilbert. II. Seguin, Fernand,
1922-1988. III. Title.

ND249.R5A3513 1995 759.11 C95-930333-2

Cover Design: Brant Cowie / Art Plus Limited
Typesetting: Kinetics Design & Illustration
Printed and bound in Canada

House of Anansi Press gratefully acknowledges the support of the Canada
Council, the Ontario Ministry of Citizenship, Culture, and Recreation,
Ontario Arts Council, and Ontario Publishing Centre in the development
of writing and publishing in Canada.

Contents

PREFACE

It's not every day that Jean-Paul Riopelle agrees to be interviewed. And when he does, it is not at all certain that he will play by the rules. Journalists who have met him have learned this to their cost, those who have had to contend with his abrupt changes of subject, his silences, his quips, and his inconsistencies.

Early on, Riopelle explains himself: "When people look for philosophical answers to simple questions, nothing good can come of it. The same thing for memories, what I like to call my 'intimacy.' To recall the past, meetings that made their mark on me — and this is what journalists don't understand — is to exercise my right to make mistakes, to get things wrong . . . I have the right to stray from reality, not always to stick to the truth. Once you allow that, however, you also have to let me change the subject whenever I choose, so as not to go on sabotaging the truth for too much longer. Intimacy, what one

reveals of it, must be coherent. Your memories can be inexact, but there's a limit . . . Beyond that, it's better to keep silent."

And so we should not be surprised to find, on occasion, that dates are inaccurate or events confused, for that is how these things appear in Riopelle's mind and shape his understanding of the world.

These discrepancies — and they are rare — do not detract in any way from the importance of the interviews that follow, not only because such interviews are so few and far between, but also because their subject's stature must be borne in mind. Jean-Paul Riopelle is, without a doubt, one of the great painters of our century. He is the only Quebec artist whose work has a truly international reputation, and since the 1940s he has been a participant in the most innovative art movements of his time.

Riopelle is seventy-two years old, an age for reassessment, for analyses that can at times be painful, for regrets, for the savouring of past pleasures, and for the occasional settling of scores, never out of malice, however, and never selling short the integrity of others. From the *Refus global,* of which he was one of the cosigners in 1948, to his most recent work (*Homage to Rosa Luxemburg* at the Galérie Michel Tétreault Art International in October 1993), the artist, in this interview with Gilbert Érouart, writer, art historian, and friend,[1] takes stock of a life informed by some of the most original and creative art and literature produced over the last fifty years: Borduas, Breton, Giacometti, Beckett . . .

Along with this recent interview is one that Jean-Paul Riopelle accorded Fernand Seguin for Radio-Canada television twenty-five years earlier, in 1968. The two conversations complement and complete each other, and together contribute to our understanding of the painter, his career, and his idea of art.

[1] Gilbert Érouart is preparing, in collaboration with the painter, and at the request of the Imprimerie national de Paris, an eagerly awaited "artistic testament."

Riopelle
In Conversation

I
THE RIOPELLE MYTH

"When by chance one can recount something absolutely true that does one as much credit as a lie, the pleasure is particularly exquisite."
Jules Romains, *Men of Good Will*

GILBERT ÉROUART: How shall we begin?[1]

JEAN-PAUL RIOPELLE: I'll ask the questions and you give the answers . . . How about that?

ÉROUART: Right. Journalists claim you're impossible to interview, that you're perfectly capable of answering yes and no to the same question. That because you're always so elusive, it's a futile exercise.

RIOPELLE: Not necessarily. With the art critic Pierre Schneider,[2] the results were excellent. When people

look for philosophical answers to simple questions, nothing good can come of it. The same thing for memories, what I like to call my "intimacy."

To recall the past, meetings that made their mark on me — and this is what journalists don't understand — is to exercise my right to make mistakes, to get things wrong . . . I have the right to stray from reality, not always to stick to the truth. Once you allow that, however, you also have to let me change the subject whenever I choose, so as not to go on sabotaging the truth for too much longer.

Intimacy, what one reveals of it, must be coherent. Your memories can be inexact, but there's a limit . . . Beyond that, it's better to keep silent.

ÉROUART: For example . . .

RIOPELLE: Beckett. We would talk for hours. He provided the fuel: a particular brand of whiskey. Irish, of course. Now I cannot remember the name of this whiskey, important as it was to Beckett. It's infuriating. How can I talk about Beckett if I can't talk about his whiskey, if I don't know what it's called. . . ?

ÉROUART: Let's get down to business. The Riopelle myth — the Bugattis, your boat on the Mediterranean (the *Serica*), the astronomical sums some of your paintings have garnered in recent years ($14 million U.S. at Sotheby's in London for a 1953 canvas; an estimated $3.5 million U.S. in New York for the 1949 *Grande Composition*!) — how does this myth relate to reality, your inner reality, in particular? In other words, do we have here the *willed* fulfillment of a destiny?

RIOPELLE: I wanted to become an engineer, an automobile mechanic. Or a professional hockey player. I became a painter. We're always struggling against

something. I was talking to you recently about Olivier Debré, who just completed a sculpture for Montreal as a tribute to General de Gaulle. In his family, did they want him to become an artist? His father, Professor Robert Debré, the distinguished pediatrician, was he in favour of it? Was he opposed? Medicine is one field, art is another. And then Olivier Debré's brother, Michel Debré, was de Gaulle's prime minister. He couldn't have always found that easy. He must have met resistance here and there. It's not always simple to become a painter. But the hardships don't stop you from becoming a great artist — on the contrary. Debré, in any case, is certainly that.

ÉROUART: Your Bugattis. An art critic who once rode with you spoke eloquently of "the impromptu braking and the rhythmic manoeuvres" of Riopelle the driver. Was that a polite way to describe your improvisations at the wheel?

RIOPELLE: No, I was a very good driver. In my own way. I had, I still have, a great love for the world's most beautiful automobiles. There are still a few in my garage at Saint-Cyr, in France, and their engines are turned over on a regular basis. Speed? Yes, I raced cars, and seriously. But I also flew planes. And rode motorcycles. I know all about speed. The greatest racer of all was Sterling Moss's sister. Not Sterling himself. He was just world champion . . . There's a garage named after me, still, near the course at Bridge-Hampton, in the United States, in honour of my starting last, and finishing . . . a good last. It was to be expected; my car was the least powerful. I got a hand all the same; I was treated with respect. That's the automobile for you: a moral code, a code of ethics.

ılls always lets a Bugatti pass — at least that's the wʌy it should be.

ÉROUART: Your sailboat, the *Serica*, the *Serica-Junior* to be precise. You haven't taken it out for a long time . . .

RIOPELLE: It's in dock, at Golfe-Juan. But it too is being maintained. I don't want to go out on the water unless I can handle the sails myself. It's a wonderful boat, the *Serica*, a replica of a nineteenth-century English design. It stands up beautifully to Mediterranean storms, which are among the most dangerous: when they come up you have to steer in close to shore, quickly, where it's deep, near the cliffs. Near the Libyan beaches the risk is greater, because of the sand.

When you go to sea, you have to know how to lay up provisions for many weeks. After that, you can live anywhere, very simply. Here, on the Ile aux Oies, it's like being on my boat; I can withstand long sieges, spend the winter if necessary. An island is a sailboat without a mast. In any case, my sailboat is my painting: I got it in exchange for a few Riopelles that went to Pierre Matisse, my gallery director in New York — son of the painter.

ÉROUART: Exactly. The astronomical prices some of your paintings have gone for . . .

RIOPELLE: I've had painter friends, Wols for example, who sold wonderful canvases for pitiful sums of money. It was unfair. Wols and how many others . . . and all with tremendous talent!

ÉROUART: Why was it unfair? In painting, the price is related to what? To talent, to the longevity of the artist? To the intrinsic value of the work?

RIOPELLE: To the talent of the dealers. Nothing else.

ÉROUART: Luxury hotels and the good life in New York, Paris, Venice, wherever. Is that all true, as well?

RIOPELLE: I'm the one who introduced Gauloises bleues, unfiltered, into the great hotels of New York. You can find them there now, see for yourself. But here in Quebec, where they're made, they're harder and harder to buy. I'm not going to go all the way to New York just to buy cigarettes. Maybe you can find me some . . .

ÉROUART: One gets the impression that you've been everywhere in the world, met everyone worth meeting. Riopelle, the friend of Beckett, of Breton, of Giacometti. Isn't that just a lot of talk? Stories made up after the fact, without much to them?

RIOPELLE: Not at all! I've had friends, great friends, and whether they're famous or not is of no importance. It could be the people you just mentioned, or it could be a car mechanic, someone I met in a café, or Jackrabbit Johannsen, who died at 111 and never took off his cross-country skis, not even at home. Very different people. Those in the profession, of course, dealers like Pierre Loeb, Nina Dausset, or later Pierre Matisse, Maeght . . . Critics too: Georges Duthuit, Matisse's son-in-law, Pierre Schneider, or Cravan — he was afraid of nobody; he attacked everyone, dared to say right out that if he met Sonia Delaunay, then at the height of her fame, he'd apply his hand to her bottom in public to show her how he felt about her latest work. I had lunch practically every day with Beckett: we tried to cheer up Bram van Velde, who was not in very good shape. I spent whole nights at La Coupole, talking with Giacometti. At dawn we couldn't even remember what we'd discussed. It didn't matter. The important thing was to see each other, and to drink together. Certainly not to have prepared subjects of conversation.

ÉROUART: Theatre people, too?

RIOPELLE: I met Antonin Artaud, who was staying with Loeb. Other actors, playwrights, poets . . . But I was never that taken with the theatre. Those people frightened me. At the premiere of *Waiting for Godot*, I "waited" for it to be over, at a café terrace across the street. At the same table, there was someone else to share my anxiety — Mr. Beckett, himself!

I met a lot of musicians. There are very very few good conductors. And not many good orchestras, either . . .

ÉROUART: There are no musicians that you found interesting?

RIOPELLE: Yes . . . the composer Betsy Jolas, Messiaens's friend. And a few others, perhaps. The fantastic jazz musician Vic Vogel, who's just composed a piece for me called "La côte sauvage" ("The Wild Coast"). And then Arthur Honegger, and his extraordinary *Pacific 231*.

ÉROUART: Let's go back to artists, painters, sculptors . . .

RIOPELLE: There's no end to them, naturally. I've mentioned Giacometti, Bram van Velde. I'd have to add Zao Wou-Ki, Mathieu, Hartung, Vieira da Silva. Also de Staël, Charchoune, Miró, Calder, Arp, Atlan, the Americans. My old friend Sam Francis, of course . . . I can't remember them all. But I was not specifically seeking the company of painters. I regularly got together with people like Aimé Césaire, Picabia, and others in a café on the rue de Dragon. But also with writers, engravers, sculptors that were not that well known, not so sought after, some not at all. Good and bad artists. People.

ÉROUART: There is a survey from 1961 that has often been cited. It was published in the revue *Connaissance des Arts*, and those sampled were an informed public, people from what was considered the "art world." From that moment on, you were numbered among the "masters" of contemporary art, not far behind the sacred cows — Picasso, Braque, Miró, Dubuffet — but ahead of Dali or Franz Kline, and on the same level as Giacometti! So one could legitimately refer to Riopelle, subsequently, as one of the "old masters": and you were only thirty-eight years old. A few years later came the famous photograph by Yousuf Karsh, recently acquired by the Montreal Museum of Fine Arts, where we see a somewhat Hollywoodish Riopelle, lost in thought. Is this narcissism? Are you weighed down by fame?

RIOPELLE: I remember that photo session. The photographer insisted on enhancing the mood with the smoke from my cigarette. We tried over and over. What a business. I think eventually he pulled a fast one. I'm not sure it's me in the photograph.

As far as masters are concerned, we all have them. Direct and indirect. Cézanne? Corot? Some Gauguins, many great canvases by Courbet. A few years ago I paid a visit to Van Gogh's grave at Auvers-sur-Oise: that pilgrimage meant a lot to me . . . I'm moved by other great painters of the nineteenth century as well, but to different degrees. Delacroix and Géricault? Victor Hugo's drawings. And for so many reasons, Monet: the light alone!

ÉROUART: Monet above all?

RIOPELLE: Above all? No. The strongest influence was perhaps Vuillard, the very "Nabi" Vuillard,

decorative, the painter of screens. No . . . the greatest is still Matisse, the only painter to have explored all possible techniques.

Luckily for the abstractionists, Matisse did no abstracts: he would have demolished everyone.

ÉROUART: And earlier? The Renaissance? No Italians, Spaniards, Northern masters?

RIOPELLE: My feelings changed from year to year. I've always been moved by those who were able to transcend the system that constricted them — Rembrandt in a few works (*The Nightwatch*, or *Daywatch* if you prefer: the painting is just as beautiful before or after the restoration!), a Velasquez, a Vermeer. All that, yes. The Italians? I don't know . . . the Lorenzetti brothers, Piero and Ambrogio, and the Sienna school. The Lorenzettis were extraordinary! What painters!

ÉROUART: And the moderns?

RIOPELLE: Everything's already been said about them. You can't help being influenced by your contemporaries. I owe a great deal to my Quebec masters. Ozias Leduc, whom I went to see in his retreat at Saint-Hilaire. He was nature incarnate. Canvases that embraced all the seasons at once. Leduc painted trees magnificently, clothed them differently all through the year. What a triumph, in the end! And Mary Bouchard also, "Mémé Bouchard." I have a painting of hers that's very important to me. There was also John Lyman, a remarkable colourist. Further back, Suzor-Coté . . .

ÉROUART: And Paul-Emile Borduas, of course?

RIOPELLE: Of course. He was my teacher when I was a student at the École du meuble in Montreal, at

the beginning of the forties. Borduas had a tremendous influence on a whole generation of painters. The *Refus global* was him. And when that text was published by my friend Maurice Perron, the directors of the school tossed him out. They treated him horribly. A great painter . . .

ÉROUART: He could have, he was to have been part of the international surrealist exhibition organized in Paris, in 1947, by André Breton. Was this not an opportunity missed, to bring together Quebec, Canadian, and European artists?

RIOPELLE: Borduas showed a little later at the Galerie du Luxembourg. The exhibition was called "Automatisme." Some of those who signed and supported the *Refus global* participated: Mousseau, Leduc, Barbeau, myself . . . As for the exhibition organized by Breton, it was of course too bad that Borduas's paintings were absent. But it was his decision, and it had to be respected.

ÉROUART: André Breton . . . He must have been an overwhelming presence for a young painter just arrived in Paris. He soon had you labelled: the "peerless trapper." Quite a tribute from the pope of surrealism. Was it not a heavy burden to bear?

RIOPELLE: If you want to understand what he meant, you have to quote the whole passage.

ÉROUART: Breton said something like this: "Riopelle's painting is the art of a peerless trapper. Traps for beasts of the earth and of the skies. Traps for the traps. It's when those traps are snared that real freedom has been achieved."

RIOPELLE: Yes, it was something like that. I was a "peerless trapper"; but Breton was the pope: not bad,

either, to be "pope"! At first glance, the man was full of contradictions. He didn't express himself simply, but in the long run, he always chose "*le mot juste.*" He wrote *Arcanum 17* in the Gaspé, in the early 1940s. I was painting not far off at the same time, at Saint-Fabien, but we didn't yet know each other. The birds he refers to in that book are those of Bonaventure Island, off Percé. The rock at Percé, the ship with glass propellers . . . His trip to Quebec made a big impression on Breton. In his apartment in Paris, he had an amazing collection of Indian and Inuit masks. Pierre Loeb, my dealer, introduced me to him. I admired Breton immensely. But I also thought, and he admitted it himself later on, that he had acted unfairly on many occasions: the time, for example, that he excommunicated Matta — this was in the days of the famous "*cadavres exquis*"[3] — because he applied his painted buttocks to the ground! Unfair! Totally intolerant!

ÉROUART: There was also the day in 1934 when he almost expelled Dali for his painting *The Mystery of William Tell*, which was in fact a satire on Lenin decked out in the famous "anamorphic rump, made into bread, and soft at the end"?

RIOPELLE: Dali, for his part, was dying to be expelled!

ÉROUART: There's no question but that you admired Breton. In the house on Ile aux Oies where we're talking right now, there is only one "image": there, over the kitchen door frame, is Breton's head, a black-and-white photo, Breton with a red collar button like a small spot of blood. But let's go back to the "peerless trapper." The phrase is a bit mysterious for the uninitiated. In the mind of its author, does it refer to the world, to your Canadian culture, to the wide horizons of Quebec?

RIOPELLE: When a very young Indian falls into the water for the first time, the others let him fend for himself. For the most part, he doesn't drown. He starts to swim. In time, he makes an excellent fisherman. He mimics the fish, and is just as good in the water . . .

In a car, it's the same thing. You have to become the motor before you can really know how to drive. And in painting? In painting, it's no different: you have to become the canvas as it takes shape.

The Indian no longer needs a trap: he *is* the trap. That's one way of looking at what Breton says . . .

ÉROUART: A car, a canvas: how can you say they are the same thing?

RIOPELLE: They're *almost* the same thing, but not quite. When I learned, in 1985, that I had just won the Grand Prix for painting offered by the City of Paris, I replied that I would have preferred to have won the Monaco Grand Prix for car racing . . .

You can make a few mistakes at the wheel: they can be corrected. Not when you're painting. If I dared to paint my series of icebergs in the 1970s, it's because the colour white doesn't exist in nature. If snow were really white, no painter would be able to render it. If snow were white, I wouldn't have taken the chance.

ÉROUART: Painting and sculpture: are they separate creative universes?

RIOPELLE: A kid can make a snowman. There's direct contact between his hands and the snow. No implement, no tool. He's expressing a need . . . like the young Indian whose instinct is to swim like a fish. Painting is more difficult. Each canvas automatically cancels out the one before. The painting that counts is the one to come . . .

Érouart: Would you have been a "bad" sculptor?

Riopelle: I don't think so. I take my sculptures very seriously. More than my paintings, in some ways.

Érouart: What is difficult in painting? The much touted "impossible balance"?

Riopelle: Balance? Fernand Léger found it easily enough. And Miró, and Gorky, and Matta in the 1940s and '50s. The balanced canvas is the one that no longer needs its painter. It exists all on its own in its corner, independent even of its creator's gaze. No need for a catalogue, a label, an exhibition . . .

Érouart: No need to give a painting a name, no need for a signature?

Riopelle: A signature? Pointless. Every time I've signed a canvas, I've felt silly. You don't stop the evolution, the development of a canvas by signing it. The canvas belongs to itself. It's its own, not the painter's. A signature is grotesque. It means: "I've finished!" Finished what? Stupid, no?

Érouart: We'll come back to painting in a moment. Literature: that was Breton. Was it also Beckett?

Riopelle: When Peggy Guggenheim talks in her book about a certain "Ablamov," this "Ablamov" is Beckett. Ah, the secrets in writing . . . One of my friends got a look at the letters written by Matisse to another painter. He talks about those around him, about his family, in ways you would never suspect. He's hard on them, very hard. He would have liked to have had children that were real musicians. All this frustration that comes out in his correspondence . . . The written word is denser than the spoken word. More meaningful, more peculiar. It's a strange power, that of the writer, of literature . . .

ÉROUART: You haven't answered my question about Beckett. For you, painting is first and foremost Matisse. But literature? Who would be literature? Proust?

RIOPELLE: He's as great as Matisse. Proust is all classicism, deeply rooted, but forever inventive. Proust writes — says — everything. You were talking about Françoise Sagan not long ago, how hard she finds it to describe concretely, in words, with precision, how Proust is, for her, a great writer. I understand how difficult it is to come up with the right words to portray Proust. I knew Sagan when she was with Bernard Franck. She lived in Paris, not far from where Colette used to live. An interesting woman, Sagan. I like the idea that she had a hard time expressing her admiration for Proust. What could I say that would be comprehensive, intelligent even, about Van Gogh, Courbet, Monet? It's when I visited Van Gogh's grave that I understood I knew very little about him. His burial site at Auvers-sur-Oise is utterly simple. Vincent lies next to his brother Théo. Over them ivy grows, and that's all. What perfection! Monet? I lived where he lived, exactly, the same surroundings, the same house, the same air, the same light . . . But I know nothing about Monet, so little. But to get back to Sagan. What did she say about Proust, exactly?

ÉROUART: I'll quote from memory: "I like all the substance, everything he says, the way he's determined to unearth everything, dissect everything . . . In Proust, there's this quest, common to everyone: to find someone with whom to share a little life . . ."

RIOPELLE: Perfect. There you are. Marvellous. That's got it all. Beckett and I . . . Giacometti and I . . . What

did I want from them? What were they seeking from me? "To share a little life." Sagan says it perfectly. Life is nothing more than this stubborn desire to share the existence of another; to be accorded just a bit of this life so different from one's own, so like it as well . . . We are always alone in the world.

ÉROUART: Let's stay with Proust for a moment. You're reading everything you can find on him. There's nothing you don't want to know: what he had for breakfast, what sort of sheets he had on his bed . . . Why such an interest? Is Proust a kind of demigod, a literary colossus? Someone almost superhuman?

RIOPELLE: No. Louis Cyr, Alexis Le Trotteur, they were superhuman. They're Quebec heroes. Louis Cyr was a Hercules who climbed a ladder with a pony under his arm. Alexis Le Trotteur had an unusual build: his legs were so long that he could run faster than a horse. He raced trains, and always won. Cyr, Le Trotteur, and Jackrabbit Johannsen, with his cross-country skis in his house, who bounded across the snows like a hare — those three were out of the ordinary, "superhuman," as you said. Proust — and that's what is hard, that's the achievement — he's exactly human scale. From that height he sees, understands, everything. From that height, he writes. The others, ordinary writers, write from a sitting position. Him? From eye level. No more, no less.

But the problem with Proust is that he managed perfectly what he had in hand. That was enough for him. The one who was greater, greater than Proust, was Ferdinand Céline. Céline invented his own language. He surpassed everybody. I knew Céline and his cat well. An incredible character, out of the ordinary.

ÉROUART: Friendship, a word about friendship. You were talking about your "friend" Beckett, your "friend" Giacometti . . . You use the word "friend" a lot, but at the same time I have the feeling you're very selective in your friendships. I was going to say "pitiless" — which is not appropriate, since you never really say anything bad about anyone. What is friendship? The dictionary definition is very terse: "Friend: someone with whom one is linked by a bond of affection."

RIOPELLE: I like it when things are hard to define. The academicians must have scratched their heads to find a definition that would work. They're rather solitary people in private life . . . What is a friend? A milestone in life at a particular time. The little bit of "shared existence" we were talking about earlier. Giacometti gave me, that sleepless night, a bit of his life; and I did the same. My friends, Maître Garson for example, are those who have continued to see me, wherever I am, never mind the distance or whether I'm sick. After long separations, sometimes. But sooner or later, the faithful rendezvous, a little life shared again. Breton took off in search of Cravan when he disappeared. No one knew where he was. Breton didn't find him. Cravan — so it was said at the time — probably killed himself in hiding. He disappeared without a trace; he found a way to *really* leave the earth. And behind him, looking for him, a man. A friend.

Friendship is a special kind of solitude, a solitude split in two. Try to explain that in a dictionary.

But friendship also has its blind spots, its failings. There are those who drop out along the way, who stab you in the back the first chance they get.

ÉROUART: Friends . . . places . . . Are there places

devoid of friendship, devoid of meaning? Places are important for you, for your work. Is their choice crucial? At the moment you're on an island, Ile aux Oies, right in the middle of the St. Lawrence River. You live here alone with Huguette, your companion, and your dog Ivan. I can understand your passion for the geese, and the exceptional quality of the light. But there's also, or at least there seems to be, this overwhelming solitude, a relentless winter lying in wait . . .

RIOPELLE: It's paradise. The most beautiful thing in the world. The geese bring on the first snow (it's about time meteorologists understood how nature works: winter doesn't drive away the geese; the geese give their consent for winter to appear on the scene). Winter? I want to spend it here. They say I'm crazy. You'd be the first to say it. The house is heated. I have wood. No telephone. Don't need it: certainly not one of those horrible cellular phones! I know, there'll be no more communication with the next island, Ile aux Grues. The snow will cover everything. There'll be no distinguishing the land, the shore, the river. And I have no snowmobile. In the eighteenth century, the eldest son of Bécard de Granville and his sister Geneviève lived nineteen years right here. They were alone on the island. Their solitude could not have been much less complete than that which awaits us, Huguette, Ivan, and me. The Bécards had no snowmobile either . . . I'll be cut off from the world? Look out the window. Everything's there. What more do you need in life than that light. . . ? It's the world that will be cut off from here, not the opposite!

ÉROUART: The light on Ile aux Oies, is it more important for Riopelle the painter than that along the Seine?

RIOPELLE: You're right, there are distinctions to be made. The light along the banks of the Seine, that of Claude Monet, of the impressionists, is perhaps more *elemental*. This, along the shores of the St. Lawrence, at this point along the river, is more immediate. More "luminous," especially when it beams down through the north window, into the studio . . .

Yes, one day I'll have to revisit the banks of the Seine. Here, it's the luminosity. There, it's the *light*.

[1] The interviews were recorded on the Ile aux Oies (literally, Island of Geese) during the autumn of 1992 and the beginning of the following winter.

[2] Pierre Schneider, "Riopelle," in *Les dialogues du Louvre* (Paris: Denoël, 1972), 181–205 (reprinted Paris: Adam Biro, 1991).

[3] Literally, "exquisite corpse," a surrealist game in which the participants, each in turn, add to a drawing, which is revealed in its entirety only at the end.

II
"I BELONG TO THE ISLAND"

"The artist is only an artist on condition that he be double, and be totally cognizant of his dual nature."

Charles Baudelaire, *Esthetic Curiosities*

ÉROUART: To go away? To stay put? Is that the perennial conflict for a painter?

RIOPELLE: Sometimes I say that I'd like to go and live on Saint-Pierre and Miquelon. There I could find my Gauloises bleues, unfiltered. What with all the problems with the fisheries, and the Americans wanting the oil, de Gaulle is going to have to come back and reconquer this bit of French territory . . . I'd like to set up my foundation there, a "Riopelle Foundation,"

where young artists could come and work in peace. I passed through Saint-Pierre in 1947. To be exact, I saw Saint-Pierre and Miquelon on my way to France, from the hold of the ship that had taken me on as a stableman. "First" stableman, if you please! In fact, I know the archipelago without ever having really been there. Every month I read the local magazine with news about life in Saint-Pierre. I keep up to date, you never know . . . I also dream about Albania, Ireland . . .

ÉROUART: Saint-Pierre and Miquelon: that's an odd idea, to locate a foundation where hardly anyone would ever see it. Is that a joke? Or do you just love islands? And why not here, in Quebec?

RIOPELLE: In Quebec? That's what I was promised. It was going to be in the old prison that is now part of the Musée de Québec. It was all worked out. And then it didn't happen. I was very disappointed. Politics? Perhaps. Probably. I hate politics. Elections, referendums, they bore me. But I wanted that foundation . . .

It's true, Saint-Pierre and Miquelon, we're talking islands again. But every island is different. On these bits of land, memories, histories, come and go with the tides. Nothing is permanent.

Here, on Ile aux Oies, there was once a chapel, built in 1937, I think, when Cardinal Villeneuve came to visit. Where is this chapel? It's been said, written even, that it was a wooden structure of no architectural interest. Not so, it was very beautiful. Its windows were exquisitely arched. Well, it has disappeared. The Church ought to take care of its own property. And when its heritage is on an island, it ought to be doubly "sacred." The Church has no self-respect.

ÉROUART: Do you work differently on an island than you would on the mainland?

RIOPELLE: An island is like anywhere else, and it's always different. I have to get off to a good start, know where to attack, before I can really begin to paint. After that, whether I'm on an island or on *terra firma*, time no longer exists. No difference between day and night, between morning and evening; noon is the same as midnight . . . When I paint, it's no longer the sun that marks out the day, but technical things. The colours I've ordered that haven't arrived, the paper I crave but that you can only find in Paris . . . Far too often, I'm disappointed that I can't get the materials I once could.

What painters have to work with is less and less professional. Who knows how to make colours today? And anyway, it's all so expensive. How do young painters manage? Let governments forget about grants and provide them with quality materials instead! We should learn how to make colours again, pastels, canvas, brushes: that would be a real cultural revolution!

There are no perfectionists any more. Take clothing. Today, even if it's expensive, a jacket or a coat always has a flaw somewhere — a button badly sewn on or sharp on one edge, a sleeve that's too long, pockets everywhere that serve no purpose . . . I recently bought a pair of glasses from someone. Simply because I found them attractive. I didn't change the lenses, and so I see badly with them, very badly. But they protect my eyes from the smoke of my Gauloises. There aren't more than two or three people left in the world who still know how to make glasses properly, worthy of the name. No point going to a store to get

some made. Might as well take the first that come your way, even if you can't see with them, as long as they're attractive . . .

The Quebecker Maurice Richard knew how to play hockey. After him, there were no real players. They started bashing each other around and said that's what kept the crowds happy . . . I said before that I have Matisse's palette . . . yes, but I also have a tool that was very important to him, his penknife! It's a lack of perfectionism and, even more, the loss of basic skills that rule our lives today. We can't play hockey any more. We don't know the value of a knife . . .

In that sense, the world's inside-out. What's down is up.

ÉROUART: You've moved around a lot in your life. Studios far and wide. New York, Paris, Vanves, Vétheuil, Montmartre, Saint-Cyr, Lake Masson . . .

RIOPELLE: And Ile aux Oies . . . I've come hunting here for a long time. I'm here for the geese. Like them, I belong to the island. To have a drink at the "Bateau Ivre," the restaurant set up on a wreck on the other side, on the headland of Ile aux Grues, and to watch the sun sink into the Saint Lawrence . . . To be there with Rimbaud . . .

But nature is still a mystery: you never see it whole. It's like me, always slipping away. But understand — nature doesn't run from anything: it just decamps.

ÉROUART: Are you here for the water, even more than the geese? Would the painter be more of a sailor than a hunter?

RIOPELLE: Sailing is as hard as calling geese, it's just as mysterious. The knowledge in either case is often secret. The Indians mimic the cry of geese in a totally

different way from other hunters. The two calls have nothing in common. And yet, if you're good at it, both can be effective.

For the moose, it's even more difficult. You have to call every half hour. You don't see him, but he hears you. As long as you feel he's getting closer, you have to make him believe that you too are a moose. You make yourself into an animal, an animal with horns on its head that would break off branches if it were moving about. That's the secret: the branches you're supposed to be breaking must fall from the right height. The distance they fall, the time they take to touch the ground: that's what the moose is listening for. If he finds it "believable," then he will also believe there's another male there, a powerful rival . . . jealous, furious, he will come . . .

You want to hunt a moose? You have to be a moose. That's not for everyone. I've drawn all that. The print is called *Champlain Hunting the Moose*. There are also cat's-cradles. Very important, cat's-cradles, for the Indians and Inuit; their skill in this area is profound . . .

Most people here in Quebec have Indian blood but don't want to admit it. They're wrong. They should even know the name of the tribe from which they sprang . . .

Cat's-cradles, hunting, fishing . . . Tying flies: that's an art. It's an art, and the greatest artist in this field is my friend Paul Marier: I'm going to pay him homage very soon.

ÉROUART: Does the period of "Ficelles et autres Jeux" ["Cat's-cradles and Other Games"] represent an important phase for you? Is there a hierarchy in your work? High periods, low periods?

RIOPELLE: Important, yes, my cat's-cradle sculptures. For me at any rate. A hierarchy? I don't know. No. Nothing counts. Everything counts . . .

ÉROUART: Abstract, figurative?

RIOPELLE: Nothing abstract, nothing figurative. No lyric or geometrical phases. No surrealism. No action painting. No major or minor periods.

My most "abstract" paintings, according to some, are for me the most figurative, in the true sense of the word. On the other hand, the geese, owls, moose . . . Those paintings into which people read meaning, are they not more abstract than the others? Abstract: "abstraction," "to abstract," "to extract from," "to derive from" . . . My approach is the exact opposite. I don't take anything *from* Nature, I move *into* Nature.

The truth is, there's no abstraction in painting. Turner came close, Monet also . . . Vuillard even more. Abstraction is impossible: so is the figurative. Paint the sky? Forget it, you haven't got a hope! You could try it on one condition, that you've never seen the sky. In that respect, as I've said, I'm less an impressionist than a depressionist. I depart from the real only as much as I have to: I don't put it behind me entirely. I keep my distance where reality is concerned. What distance? The right distance . . .

ÉROUART: Let's go back to the surrealists for a moment. How is it that you were able to exhibit with them in 1947? Were your paintings surrealist?

RIOPELLE: Beware of classifications and categories . . . You know who talked best about surrealism? A painter who was quite religious, quite mystical: Bazaine. What he said about surrealism is more profound than what the surrealists said themselves. I've

been stuck with all kinds of labels. Critics have tried to associate me with all sorts of schools, trends . . .

ÉROUART: You did, after a fashion, participate in the drafting of the *Refus global*. You signed and cowrote the text. You showed along with the automatists, with groups that were more or less homogeneous, such as at Nina Dausset in 1947, where you were hung along with Tobey, Rothko, Mathieu, Pollock . . . ? You exhibited in 1951 at the request of Michel Tapié, in a show called "Véhémences confrontées": there were de Kooning, Hartung, Bryen, Capogrossi . . . Even better: in 1947, you participated along with Ubac, Brauner, Fernand Leduc, and others in an exhibition at the Galerie du Luxembourg. The show's title was very significant: "L'imaginaire"! These groupings, these slogans, can't be dismissed, they mark an artist. However independent he would like to be later . . . However independent he wants to be today . . .

RIOPELLE: Yes, yes, of course. So. What counts? What's important? What one is doing as one is doing it: my recent work counts just as much as my earliest. In a way, even more!

ÉROUART: Will critics soon come to realize how modern your paintings are of geese? As they did for late Matisse with his large blue nudes, and *Jazz*?

RIOPELLE: It's bound to happen, or it will show they've really understood nothing. There are people today who would like to paint birds the way Audubon used to. Which is silly: Audubon killed his birds, to be able to paint them better. Now that's forbidden . . . Riopelle today is not Riopelle yesterday . . . I once gave Gobelins a pastel to use as a model for a tapestry: the result was a disaster. Miró showed one

of the tapestries made from his work, wrong side out. He turned it around on purpose so the knots and hanging threads were all you saw. The result was interesting.

There are no rules in art. There is only knowledge one decides to use or not. The geese represent my strongest work. People will realize that . . .

ÉROUART: Can one trust nothing? No one? Is it only the light that never betrays a painter . . .?

RIOPELLE: The light? Not even that! In theory, I need the northern light when I work. But once I'm off and running, I lose all sense of time, and sometimes I end up painting by night . . . Then, without really noticing, I use electric light or gaslight as though it were natural light. It's absurd: but the world doesn't stop turning. I delude myself, and go on painting.

ÉROUART: And art professionals? A German friend told me he advised the curator of a Berlin museum a few years ago that the large Riopelle hung in the entry hall seemed to be upside-down. After checking, the curator told him he was right . . .

RIOPELLE: So I was right not to sign that painting! You can put too much stock in appearances. One of my Paris friends, an Argentine artist, was also a pimp. His work was much admired. But when he died, there were only three or four people at his funeral: for the rest, it was the pimp that was being buried, not the painter . . . The best pastis is not to be found in Marseille, but in a little inn near the Pont du Gard . . . A kid, once he's learned his times tables by heart, hasn't a hope of becoming a great mathematician . . . On an island near here there's a fellow who almost died from drinking too much alcohol. After taking a

cure, he decided to work as a barman, so as never to fall off the wagon. He thought, and he was right, that the only way not to return to his old habits was to serve drinks to others . . . Unbelievable, no?

Life is unbelievable! So, why not hang a painting upside-down? Especially if you're a museum curator! It's even logical, I wouldn't deny it.

ÉROUART: I'd like to go back and forth in your life. First some people, some individuals. We were talking recently about Pierre Elliott Trudeau. He's being violently attacked these days . . .

RIOPELLE: He can take care of himself! It's the others who don't know how to deal with him . . . he gets under their skin.

ÉROUART: You have close ties with him. He's unusual among politicians, both here and elsewhere. But politics is not your world. Have you ever even voted?

RIOPELLE: Voted? Absolutely not! I've only voted for myself. No one else!

ÉROUART: Pierre Elliott Trudeau . . . who is he for you, then? A politician? A man? An aesthete?

RIOPELLE: Hard to say. Politics is stupid, but Trudeau was intelligent enough to sign the Stockholm Appeal. When you meet another politician with the courage to do that, you can say: "There's a friend of Riopelle!"

ÉROUART: Were there so few politicians who signed the Stockholm Appeal?

RIOPELLE: In other countries, I don't know.

ÉROUART: Were there not others in Canada, others in Quebec?

RIOPELLE: Perhaps there were, but I don't know them . . . Yes, I suppose there were others. What I

know for certain is that he, Trudeau, signed the appeal. That's good enough for me.

ÉROUART: Talking about people . . . The dealers, always important in an artist's life — were they anything more for you than just dealers? And the collectors? Were they anything more than collectors? The relationship between the artist and that milieu is often ambivalent. It seems that it was not quite the same for you, that you were even quite close to most of them?

RIOPELLE: I was always close to my dealers because our relationship was always based on shared "opinions." When my dealers' opinions changed, I changed dealers. Emotional bonds have always been important to me. Once they're violated, I make a clean break. And I don't forgive. It's the same when my friends are attacked: I don't pardon the aggressor.

ÉROUART: Where collectors are concerned, there's no getting away from these "bonds." Riopelles are, or have been, collected by whoever wants them, notwithstanding your opinion, or your consent. And perhaps that's just as well.

RIOPELLE: Now, yes, but not at the beginning, because I was not thought of in terms of my "value" then, but simply as one artist among others. As someone it would be good to know. As a human being rather than a financial investment.

ÉROUART: Were your first collectors people who, like the dealers, shared your opinions, or did that have no importance?

RIOPELLE: No. They weren't collectors at the beginning. They were just friends. Naturally . . . The first person from the milieu who took an interest in me was Pierre Loeb, the gallery owner.

ÉROUART: Pierre Loeb . . . Pierre Loeb as dealer rather than collector?

RIOPELLE: He was always a collector. Our ties always had to do with our political positions. Pierre Loeb was someone who, for a number of reasons, felt strongly about the "state."

ÉROUART: The state?

RIOPELLE: Yes. He was Jewish. The State of Israel was just then being founded. Picasso and the surrealists had chosen him as their dealer. Picasso helped him.

The gallery still exists, I think. At the corner of the rue de L'École des Beaux-Arts and the rue de Seine. Perhaps it's in the hands of his son. Anyway, Pierre Loeb was my first real collector. He had organized the first solo exhibition for the painter Jean Hélion, in 1932. Later, he showed Vieira de Silva . . . Some artists owe a lot to their dealer. The opposite is, of course, even more true.

ÉROUART: To talk of a collector is to talk of money. You give the impression that you have no feelings about money, no attitude towards it. Is that just an impression? Does a painter need only enough to buy his materials, his colours, and his brushes?

RIOPELLE: There's only one problem for a painter: to match his means to his ambitions. That's all. Some artists have a lot of ambition, others do not. There's no other issue.

ÉROUART: A lot of ambition as a painter, or as a man?

RIOPELLE: A lot of ambition means a lot of success. For painters, life means success: nothing else. There is no artist that ever lived or that lives today for anything but success.

ÉROUART: Success is recognition. Does that automatically mean riches? Is there no other motivation in the

life of a painter? Something less prosaic, more . . . noble?

RIOPELLE: It's money. Always money. And again money. In the modern world, all success is based on money, and on nothing else.

ÉROUART: That wasn't always true?

RIOPELLE: Not necessarily. It was a vocation for the most part. Sometimes a quest for power. I no longer see painting as a "pure" vocation. There are more immediate considerations. I mentioned earlier the problem of grants and other government support. When you let yourself be taken care of, you probably lose some of your conviction. The day-to-day takes over. Before, conviction and the day-to-day went together, they complemented each other. You sought glory, but you were "committed" . . .

ÉROUART: You never go to your own vernissages. Rarely, even, to the large retrospectives of your work. Why? Is it a game? A provocation? The fear of discovering that a part of your work does not measure up to your deepest expectations, once you see it hung? "Waiting for Godot." Are you Godot?

RIOPELLE: It's always disappointing to see what you've done. But at the same time, would there be any reason to continue painting if, suddenly, one were no longer disappointed?

ÉROUART: Riopelle's absence from his own exhibitions, the fact that he refuses to mingle with the crowd, does that mean you fear something in yourself?

RIOPELLE: [. . .]

ÉROUART: You don't want to answer. The opinions of others, of those who attend your shows . . . are they important to you?

RIOPELLE: Not at all. You can't feel the same way about a painting as the painter does himself. All judgments are based on feeling, and where painting is concerned, that is so absolutely, by definition!

ÉROUART: "Waiting for Godot" . . . Is Riopelle Godot? Is everything in life just a way to pass the time? Sometimes to savour it, sometimes to curse it?

RIOPELLE: Philosophically speaking, Godot is God. That's why he's called Godot: God. To wait for God means to wait for the impossible. No, Riopelle is not Godot.

ÉROUART: Then why these few exceptions: you were there for your retrospective at Beaubourg in 1981 . . . ?

RIOPELLE: No. I only went afterwards. Not during.

ÉROUART: And for the one in Montreal, at the end of 1991?

RIOPELLE: The same thing. Also afterwards. And even then . . . it was because they insisted, many people insisted that I go!

ÉROUART: Your first retrospective, usually a landmark in the life of an artist, was in Ottawa in 1963? The same show that went later to Montreal, to the Art Gallery of Ontario, and to the Phillips Collection in Washington?

RIOPELLE: No. It was in Venice the year before, where I represented Canada in the Biennale.

ÉROUART: Were you there, then, in the flesh?

RIOPELLE: I had to be. I had to go because I was "organizing" the exhibition of American painters at the Biennale. At the American pavilion. It was rather amusing: the artists fought so much with each other! One wanted his paintings hung in such and such a place, another wanted his work lit just so . . . They

were all my friends: they came to see me and said: "Jean-Paul, we can't agree. It's up to you to put the exhibition together. We won't get involved, we promise." I said fine, but on one condition, that you come, in return, and arrange my work on the walls of the Canadian pavilion. And that's what happened. The Americans hung Riopelle's work, and I hung that of the Americans. So that the day of the opening, no one could be found in the right pavilion. I was at theirs, they were at mine. The organizers, everybody was furious. Our attitude was exactly what it seemed to be: "You're a pain in the ass to all of us . . ."

ÉROUART: On the other hand, you were there for the Ottawa retrospective. Trudeau was not yet in power.

RIOPELLE: Yes, I was there. Probably Trudeau was there too, at the vernissage. As a rule, he was always there. He always supported me, he was loyal . . . And I remember well that his reconciliation with René Lévesque took place in front of one of my paintings. Not a total reconciliation, but at least they shook hands on that occasion. There was that.

ÉROUART: These social niceties, that you detest in principle . . . You've still received, in your lifetime, an impressive number of honours; you have honorary doctorates from several universities; you've been given medals . . .

RIOPELLE: I've also refused these decorations more than once, and not always just on principle. And I've always sent someone else to represent me. No, with one exception. It was when McGill University in Montreal gave me an honorary doctorate, along with another French Canadian, the conductor [Wilfrid] Pelletier. We went together. We were received with

great ceremony, solemnly, with an orchestra and all the tra-la-la. Everyone wept: two doctorates attributed by an anglophone university to francophones! Pelletier said to me on the way out: "I don't know how things are in painting. But I can tell you that with the number of false notes I heard from the orchestra during the ceremony, there's work to be done, my dear Jean-Paul!" It was beautifully put. Pelletier was no longer young . . . "If painting's no better off than music, my poor Jean-Paul, you're not finished yet." That's what he meant. Wonderful!

ÉROUART: Do you still find the situation so desperate?

RIOPELLE: In music, without a doubt. In painting, I don't know. In any case, Pelletier's words were certainly prophetic.

ÉROUART: Women . . . they've played an important role in your life. A crucial role, at times . . .

RIOPELLE: I would hope so!

ÉROUART: But you never talk about them . . .

RIOPELLE: We could talk about Rosa Luxemburg. That woman interests me, she interests me a great deal.[1]

ÉROUART: There are no longer any Rosa Luxemburgs today? Is that what you are saying?

RIOPELLE: There are no more Rosas. All the Rosas are dead . . .

ÉROUART: Death . . . In your most recent paintings, again with geese, it's as though they're falling out of the sky, almost like a man letting himself drop, on purpose, from a bridge. Such a brutal descent. What does it mean? Is there some morbid symbolism here?

RIOPELLE: There must be something like that. If a goose falls, probably someone has shot it. When

you can no longer fly, you must fall. And then there's coming to terms with human stupidity. The older you get, the more stupid you are.

ÉROUART: There are almost no people in your paintings. Does that mean man has no place there? Or does it mean that he's so present that to put him there would be superfluous?

RIOPELLE: I think man has always been present in my paintings, that he still is. If he were not there, my painting would be abstract. And I've never made a single abstract painting . . .

ÉROUART: The exhibition catalogue from your show at Pierre Matisse's gallery in 1955 includes an epigraph, enigmatic on the surface, taken from Radiguet's *Bal du comte d'Orgel* [*Count d'Orgel*]: "There is a colour walks about, and people hidden in this colour . . ."

RIOPELLE: If we're talking theory, "abstract," as I said before, means "to come from." The logic of my work is totally different. Diametrically opposed: "I move towards . . ." Radiguet's sentence says it all. There's nothing in the least enigmatic about it, finally.

ÉROUART: Why continue to paint? To follow through on what you've already done? Does your painting speak of you, and only of you?

RIOPELLE: If I paint, it's because I don't know how to do anything else. Every painting is independent of the others.

My pretensions are boundless. Every painting I do is the most beautiful, the most interesting. Especially if it's my latest work . . . Fortunately, nothing is ever perfect: you always have to start over. My paintings don't make a series, but each one follows from the one before . . .

ÉROUART: Art . . . History . . . You are already part of art history in this century. Whether you like it or not, you're included, and will continue to be included, in encyclopedias, reference works . . .

RIOPELLE: Don't be so sure! Some encyclopedias, yes: those where everything's decided in advance. The others . . .

ÉROUART: You're there, in miniature. A short biography, a few lines that give an assessment that's more or less accurate. If you could start over as a man and as a painter, would you alter anything? Would you change the road you've travelled up to now?

RIOPELLE: No. As for encyclopedias, they're worthless. Some artists' names are there and others not. It depends on who's in charge, who's the editor. There's no more to it than that.

No, even if I could, I wouldn't relive my life any differently.

ÉROUART: Does your life have a development? A youth, a maturity? Or is it all mixed up together?

RIOPELLE: Things just happen to you. What people call inspiration just comes to you as you're going on your way. There's no order, no organization to the work. Only disorder. But it's not a matter of chance, either. No youth, no maturity. I've never been as young as I am today, or so much in control of what I'm doing.

ÉROUART: In fact, you've embarked on a new phase, something quite strange: an amazing freshness, a complete renewal, even in your choice of colours . . .

RIOPELLE: There's only one thing you must not do, and that's to live for abstraction. You must live through things. Like here on the Ile aux Oies. I'm here

for one reason only: this place — this archipelago on the St. Lawrence, and what surrounds it — it's all so fragile. It's a land of inventiveness, brilliant upheavals, inspiration forever renewed. In every way, for me it's the most fragile place on earth. The next earthquake will take place here. It's written: in twenty years all of this will vanish, in one fell swoop. People don't want to know it, they feign ignorance. They pretend not to believe it . . .

ÉROUART: And you?

RIOPELLE: I don't believe it either, finally. If I did, I'd go to St. Joseph's Oratory right away, to seek divine protection!

ÉROUART: We're working, you and I, on a kind of artistic testament, at the request of the Imprimerie nationale de Paris. The idea originated, more or less, with Giacometti. What does this mean for a painter? A respite, a new beginning?

RIOPELLE: It's an accounting. You take stock, so as to move on again. That was what Giacometti did, with *Paris sans fin* [*Paris Without End*]. It's perhaps the most beautiful thing he ever did: the absolute beauty of his last work. That's often the way it happens.

ÉROUART: What did he do after his "testament," his "accounting"?

RIOPELLE: He died. He just "prolonged" the accounting, and then he departed. That's what I want, too. I'm paying my tribute to Alberto: I'm following his example. I'll copy him. And then . . .

ÉROUART: These artistic testaments, have others besides Alberto and yourself felt this deep need? Dali?

RIOPELLE: Dali, I don't think so. I don't think he would have been able to make an accounting.

ÉROUART: To make an accounting is to call oneself into question? To express doubts never before acknowledged?

RIOPELLE: No. You have to think of it as balancing the books. You do your accounts: credit, debit . . . You draw a line, you see what you have.

ÉROUART: Going back to people . . . Breton — again, unfathomable, omnipresent — he was buried on the first of October 1966, at the Batignolles cemetery in Paris. Five thousand people accompanied him to his last resting place: was Riopelle in the crowd?

RIOPELLE: No. For a long time, already, Breton had wanted nothing to do with me. There was no reason for me to be there . . . none.

ÉROUART: You didn't want to see him any more, either . . . Can you say any more about that?

RIOPELLE: No. I'm against all symbolic forms. It's in that light that you have to see my disagreement with Breton.

ÉROUART: A philosophical disagreement?

RIOPELLE: We always have philosophical disagreements with others. Disagreements, for me at least, are always of that kind.

ÉROUART: In this instance, the conflict — if I may use that word — went back to the very beginning? To your participation, at the invitation of Breton himself, in the International Exhibition of Surrealism in 1947?

RIOPELLE: Yes. I'd rejected the idea of altars, of "gods," with a small or a capital "g." I'd refused that kind of symbolism. I was extremely mistrustful of it.

ÉROUART: It's true that while you agreed to take part in that event — let us say in passing how gratifying it must have been for a young painter just arrived in

Paris to find himself side by side with artists from among the elite — you, at the same time, with others, exhibited elsewhere, on the fringe. The exhibition was at the Galerie Maeght, but you showed elsewhere as well, independent of the ritual pathway laid out by Breton.

RIOPELLE: Others, besides myself, were in fact hung in the corridor. The dissidence was essentially political. The great painter in all this affair was Wilfredo Lam, the Cuban artist. The symbolic character of the exhibition came from him. Lam had a great influence on Breton. His painting? Trees, a dreamlike world both anthropomorphic and zoomorphic. Picasso was behind him, encouraged him, supported him in every way. And the gallery owner Pierre Loeb also.

ÉROUART: It was an incredible exhibition whose aim was nothing less than to create the conditions for a "new mythology." The intent, according to the texts, was to fuse in the same crucible the sacred and the occult. An attempt at ritual unimaginable today. Let me quickly quote Alexandrian, who witnessed it all, so one might understand what it was you refused to participate in, keeping, in your wisdom, to the gallery corridor: "The exhibition is organized in such a way as to mark out the stages of an initiation . . . a stairway of twenty-one steps, made up of the spines of books, with significant titles . . . the hall of Superstitions . . . the cycle of ordeals . . . Further on, a room divided into octagonal cells containing twelve altars, inspired by pagan cults . . . corresponding to the Zodiac with the twelve hours of the Nuctameron of Apollonius of Thyane . . ." And so on.

How in fact did the Riopelle we know deal with

this adventure in which everyone had to "define what was sacred to him"? The whole question of your commitment, however fleeting, to the surrealist movement lies there. Terminology, again. Abstraction? Figuration? In 1946–47, around the time of that same exhibition, you made the transition from painting with identifiable pictorial elements to one without the slightest figurative reference.

RIOPELLE: I was always able to identify them, those references. That was never a problem. Among those who then frequented the art world, there was a deep-seated desire, a need for "the unknown and its magic." If the canvas was too easily identifiable, then the magical, the idea of the magical, which was what mattered, would be lost. Look at what happened with Mondrian. My friends (I was one of the rare defenders of Mondrian's work) only saw in his painting, in his right-angled lines, the bars of a prison. I thought they were wrong, but I only said: "Me, I like Mondrian." One day, one of the few people I felt was trustworthy came to me and confessed that he'd been stupid to have thought it could all be traced back to prison bars. Now he saw a city with its streets all lined up . . . You can get to the heart of something quickly or not so quickly. You can make horrible mistakes. I knew at first glance that they could not be prison bars. What, exactly? It didn't matter, but not bars . . . I was certain of that . . .

ÉROUART: The sixties saw the reappearance in your work of identifiable elements: an eagle, a tortoise, "facies," various birds . . .

RIOPELLE: When you talk that way, you overlook everything that's truly art. What you're talking about

is "references." Art is something else. It's people who change their attitudes over time, it's not the painting that changes. Between 1945 and 1960, it was not my work that altered, but others' view of it. When you see a hand in a canvas with seven fingers instead of five — but a perfectly formed hand — are you looking at something abstract or figurative?

People wanted to justify art in literary terms. That led nowhere. They thought a painter like Miró was making literature, when he was doing nothing of the sort.

[1] In the weeks that followed, Jean-Paul Riopelle was to create three immense canvases, each fifteen metres long, in honour of the famous Polish-born revolutionary (cf. the exhibition catalogue from the Galerie Tétreault, October 1993).

III
RIOPELLE REDEFINED

"I always tell the truth: not all of it, because to do so is beyond my means. To tell all is, in practical terms, impossible: there are not enough words. It is through this very impossibility that truth hews to reality."

Jacques Lacan, *Television*

ÉROUART: Going back to death . . . How do you view the recent passing of your former companion, Joan Mitchell, the superb American painter?

RIOPELLE: Death? I told you: I defer to it. I have no choice. Unless you believe in Saint Lucre. If you pray to Saint Lucre, you won't die. Or if you do, only on the day of your death. No other day, not any earlier . . .

Speaking of saints, I'd rather believe in "Saint . . . cinnati," that legend . . .

ÉROUART: Cincinnatus — the Roman peasant forced to abandon his plough to become a hero, and who preferred, rather than become a dictator, to return to his plough?

RIOPELLE: That's it. That's the heroic legend I like.

ÉROUART: Death, success . . . Are painters that eager for success? Like racing drivers? Are all the painters of our time the antithesis of Cincinnatus?

RIOPELLE: They have no choice. Everyone lives with a carrot in front of his nose, like the donkey, to make him go forward. Everyone behaves like the donkey. Painters too. Usually it's the dealer who holds the carrot . . .

ÉROUART: What for you was the decisive moment, that put you in the limelight for good? Was it when Breton singled you out? Your first retrospective? Georges Duthuit's memorable words, in 1954: "You summoned Nature, she descended, here she is." In other words: Riopelle is Nature!

RIOPELLE: That's Duthuit, that's the way his mind worked. He wasn't the only one to take that tack, but he was, without a doubt, very, very cultured.

ÉROUART: Duthuit was crucial, then?

RIOPELLE: The artists he favoured were not all recognized, far from it . . . It's always a matter of luck. What I lived was lived differently by others . . . The historical importance of the Voice of America . . . Why, during the war, did Duthuit go to New York to work for the Voice of America? Because his wife was the daughter of one of the greats in the Resistance, a certain Henri Matisse, the painter himself. Matisse was extremely active. Money for the Resistance in France

arrived from England hidden in his sculptures. Another great resister: René Char, the poet and Matisse's close friend. They were all in the Resistance in southern France. Duthuit's wife was tortured.

ÉROUART: Breton also worked for the Voice of America?

RIOPELLE: If Breton or Duthuit had returned to France, they would have immediately fallen into the hands of the Germans. Breton went to New York to serve as a broadcaster on the one condition that he never have to pronounce the Pope's name on the air . . .

ÉROUART: Other artists chose exile in New York: Matta, Tanguy, Ernst, Chagall . . .

RIOPELLE: And Zadkine, and Masson, and Mondrian, and Léger . . . I forget the rest.

ÉROUART: What is one to think of those, unlike Matisse or Char — artists, writers, others — who were accused of a certain complicity with the enemy, the Germans who were occupying France? A Cocteau, a Vlaminck, a Derain, many others . . .

RIOPELLE: Those who went along: Despiau, Friesz, Segonzac . . . they were all guilty in that respect. The problem was Spain. Franco. The real issue was there. They all attended the German affairs in Paris, Arno Breker's exhibitions, or visited Germany when they were invited. But that was not the question. For intellectuals, it was all, first, a matter of Franco! Read Malraux on the subject . . .

ÉROUART: Let's talk about painting again. We've made reference on a number of occasions to European painters. What about the Americans? What was your connection with the painters of Sam Francis's generation, living in Paris? Norman Bluhm, Al Held, Ruth

Francken, Kimber Smith, Shirley Jaffe were all nearby. Not to mention Joan Mitchell, with whom you would soon be living. And the adepts of "cropping," a Morris Louis, a Noland, an Olitski . . .

RIOPELLE: I knew all these people in New York before meeting them again in Paris. It's true, almost all of them took off at some point for France. I first went to New York for the jazz. To like jazz meant something more than just appreciating that kind of music: it meant above all not being anti-black! In New York, people were anti-black. They called them, quite simply: "the crazies." Only artists were interested in blacks. For a very simple reason: only the blacks were supporting the artists . . .

ÉROUART: Your relationship with critics . . . We know that Breton, like Duthuit, whom we were just talking about, took a number of artists under his wing, not all of whom achieved the highest recognition. Some, such as Hantaï or Degottex, yes. Others, I'm thinking of Duvillier, Judith Reigl, or Loubchansky, less so. Does that mean that Breton was more committed to Riopelle than to other young painters?

RIOPELLE: Breton was always the master, the pope. Some artists sought the pope's blessing. Others preferred excommunication, myself included: that's what you call a moral imperative.

ÉROUART: In the catalogue for the Maeght exhibition in 1966, the critic Jacques Dupin wrote: "Riopelle works in a state of crisis, in a sort of hypnotic fury and abandon." Would the painter Riopelle be different from the Riopelle I'm talking to? Would it not be the same man?

RIOPELLE: I wonder why one paints. That's all.

Although it would not be easier not to paint. When you paint, you get dirty, you dirty things, you become a "*tachiste*," as the critic Michel Tapié would have said . . .

To work in "crisis," in "fury"? That wasn't really my style at the time. That wasn't my way. Georges Mathieu worked hard and fast. Not Riopelle.

ÉROUART: You exhibited with Mathieu. It's true that the man of "psychic non-figuration" and lyric abstraction seems closer to American action painting than you do. And as a person, he seems quite different from yourself. He ostentatiously courts the public. That's more like an anti-Riopelle, no?

RIOPELLE: There's some truth in what you say . . . And yet we saw each other all the time. We spent time with the same people, in the same places. The person behind all that, again, was Michel Tapié.

ÉROUART: Another interesting comment was that of Pierre Boudreau, when you had your exhibition in New York in 1969, with Pierre Matisse: "With his access to the past, Riopelle fulfills a present need." Again this idea that you were more classical than avant-garde.

RIOPELLE: Perfect. I've never thought much of the avant-garde. You know what the avant-garde is? Those who trail after the shock troops and hide behind them. That's Borduas's image, I think. In any case, it's apt.

ÉROUART: As an adolescent you seemed to have been quite gifted in mathematics, and yet unsatisfied, uneasy with the "abstract" nature of the discipline. Was that also your point of view as a painter?

RIOPELLE: Somewhat, yes . . . In fact I tried to find a way to excel in "non-abstract" mathematics, to favour

the mechanical side of mathematics. That problem has always preoccupied me to some degree . . .

ÉROUART: The press has always credited you with a comment that turns up a little later in Borduas's writings, appended to the text of the "*Refus global*" (in a short article, "En regard du surréalisme actuel" ["About Today's Surrealism"]): "Breton alone remains incorruptible." Would Riopelle be more surrealist than the Parisian surrealists themselves?

RIOPELLE: For Borduas, the goal of art was to make a world revolution. I had no interest in revolution. My problem was not to know whether I was a communist, or whatever . . . All I cared about was that there be no cheating. Whoever wanted to promote his ideas would always cheat, in the long run. Sooner or later, it came down to that . . . Which resulted in all sorts of compromises, big ones included!

Borduas was much more committed than anyone else, and was in much more danger. He had something to lose: his job as a teacher. In fact, he wanted to lose that job. And, of course, he did. He achieved his ends. The priests ran after him to try to stop him from becoming a revolutionary. Borduas was surrounded by people who, one way or another, wanted to convert him.

ÉROUART: What do you mean, convert him?

RIOPELLE: In other words, to stop him from saying "*merde*," from going too far . . .

ÉROUART: Getting back to surrealism: whether or not you belonged to the movement is not all that simple to say. In 1948, there was your solo exhibition at the Galerie La Dragonne in Paris with the famous catalogue where, under the heading "Aparté," your work

was discussed by — no less — André Breton, Elisa Breton, and Benjamin Péret. The titles of your canvases are, at that time, incredibly surrealist!

RIOPELLE: Of course. Breton gave them their titles.

ÉROUART: Even this? "The Automatic Tigers Slept upon the Waves"?

RIOPELLE: No, that wasn't him. It could have been him, but Breton only associated the word "automatic," for the most part, with literature, with writing. Not with painting.

ÉROUART: Are the titles of paintings important? You're far from having titled all of yours . . .

RIOPELLE: I hope I get it right when I do choose one. There's a problem with titles. If you don't provide one, you lose track of the painting, in part at any rate.

At one time, Nicolas de Staël and myself (we lived together a fair bit) decided to give titles to everything. When we had no title, we used a number. Why not? But a few years later, if you see a title such as "1964. 142" (that's the one hundred and forty-second painting for 1964), it's hard to remember what was going on when that particular canvas was taking shape . . .

Even if you select a title that doesn't suit the picture perfectly, at least it leaves a trace, it's like a marker for your memory.

But at the same time, the artist's compulsion to give everything a name can end up being misleading. And neither memory nor history may ever set things straight. For instance, if you call a painting "Red-White-Blue" for reasons that have only to do with colour, later people will say — could say — that Riopelle at that point was going through a nationalistic phase. If, on the other hand, you choose "The

14th of July" for a title instead of "Red-White-Blue," the margin of error is much smaller. Even so . . .

ÉROUART: When you use Indian or Inuit words for your paintings, what does that signify?

RIOPELLE: That was an important period. And I used very specific titles, so that, as I said, I'd be able to remember. For example, I called one of my paintings (or was it a watercolour, I'm not sure) *Oka*. Many pieces could have been given this name. But for me, that name had a particular history: I went to find out from the Indians what the word meant. For them, it's "little bear." Oka, as a painting, could only be that canvas or that watercolour by Riopelle . . . Besides, the "little bear" is there. For me, it's obvious. You have to know how to read a painting.

ÉROUART: In future, art historians will think that by using that title you wanted to express your solidarity with the Indians of the Oka Reserve in their struggle with the Quebec provincial police. Time and history will obscure the facts, and undoubtedly betray you.

RIOPELLE: Very likely. I have a similar example. "Toronto" is another Indian word I've used, and it means "meeting place." The choice has nothing to do with politics. But that won't stop some people from making the following interpretation: Toronto represents anglophones, English Canada, enemy to francophones, French Canada, and so on. By calling his painting *Toronto*, Riopelle has taken sides in this linguistic and political quarrel, championing the anglophones over the francophones . . . It's all ridiculous, of course. So the choice of a painting's title is important . . . but also very delicate, extremely dangerous!

ÉROUART: Signatures . . . signing a painting . . .

RIOPELLE: It's nonsense! At first I signed everything I did. For us, the young postwar painters, the inventor of the non-signature was the American Sam Francis. There were probably others before him. But for my generation, it was him. Sam Francis signed the back of his paintings: not the front. That posed problems for buyers and speculators. Might not unsigned works decline in value over time? He made buyers nervous!

Sam Francis's approach was wonderful, he had a marvellous theory. For him, putting your signature at the bottom of the canvas could only deform the painting space. You can't argue with that. Besides, as I've already said, to sign is to add something to the canvas, to add "the end." What end?

When I used to sign it was because, like giving titles to works, I felt caught in the trap of identifying them for myself, inscribing them in memory. In fact, the signature is a cheat. A painting is already a signature. It's the only signature that counts.

Some artists think that signing paintings will make them easier to track down and identify. They're afraid people won't be able immediately to put an artist's name to what they're looking at. That makes sense for little-known artists. But then the signature is a means, not an end. Never an end.

ÉROUART: You knowingly adopt a stance, a behaviour, that could be termed anti-intellectual. On the other hand, you read early, and deeply, works which, for North America at the time, were absolute dynamite where philosophical and political thought were concerned. I suspect the law even prohibited those writings you devoured, signed Marx, Nietzsche,

Sade, Lautréamont . . . Your apparent distrust of intellectuals, is that another way of covering your tracks?

RIOPELLE: People were afraid to say they read "forbidden writers." I said it. I could have been put in prison. To tell the truth, I didn't care. I'm the one who brought all those books back from Europe. I smuggled them through, in my suitcases. And then I gave them out, I distributed them. No one asked me to do that, to take those risks. Everyone was afraid. It was the time of Duplessis in Quebec, and the Padlock Law. That's not very long ago. It wasn't 1920, it was yesterday.

In Europe, everyone could read what he liked. In Quebec, to want to change things automatically meant revolution. I didn't want to make a revolution, so I went off to explore a different reality. I crossed the Atlantic.

Nothing changed here, in North America and especially in Quebec, until very recently. Even now, a lot of things remain the same, in spirit . . .

ÉROUART: I should note also that the anti-intellectual Riopelle made his pilgrimage to the Chateau Lacoste, the dwelling place of the divine Marquis de Sade, soon after his arrival in France. That was at the end of the forties, the beginning of the fifties?

RIOPELLE: It must have been around then. Why this pilgrimage? First of all, that region, where the ruins of de Sade's castle are situated, is one of the most beautiful in the world. And then I had friends who lived nearby. Max Ernst was there, Hérold also . . . and Sade, of course! His memory was very much alive. It's true, I'd read Sade very early on. He was perhaps more taboo in North America than Marx. It was quite

something to dare to read Sade in those days, you can be sure . . .

ÉROUART: Could you buy his works in Paris without any problem?

RIOPELLE: No. Even there, it's true, it wasn't so simple.

ÉROUART: Let's go back to all the repression you had to contend with in Canada. You spoke out a lot at that time, just after the war, most often in the press. The debates ranged widely: communism, the power of the Church, surrealism . . . For the most part you say, right out, what you have to say, but nevertheless, it's hard to imagine you getting involved in those endless quarrels. Were you different then?

RIOPELLE: Ideology never interested me. You have to understand that in those days official, "authorized" quarrels in Quebec were reduced to exchanges between Jesuits and Dominicans. The communists were nowhere to be seen. No one asked their opinion: that was unheard of!

ÉROUART: On December 6 in Montreal, in the paper *Notre temps* [*Our Time*], there appeared an article entitled "Retour d'Europe: Mousseau et Riopelle" ["Return from Europe: Mousseau and Riopelle"]. On that occasion you denounced the Communist Party's influence on artists and intellectuals in the Old World. Was that anticommunism on your part?

RIOPELLE: [. . .]

ÉROUART: On December 20 of that same year, in the Montreal socialist paper *Combat*, you went on to say: "I disapprove of communists because they do everything they can not to attack our current moral values. Nevertheless I consider Marx and Engels to be the most lucid minds of their time." A convoluted

analysis . . . Does that mean communists inhibit critical thought? But there's worse, there's the Church, God . . . ?

RIOPELLE: We had come to that. Just to talk about Marx and Engels, to bring these taboos out in the open, made for a huge qualitative leap in what was being discussed. The press went along, on condition that at the end of the line the communists be condemned. Not the Church! Heavens, no . . .

There is nothing in the world more "communist" than the Catholic Church.

ÉROUART: In the *Combat* article you added: "That barrier which is Christian morality has not come down . . ."

RIOPELLE: That's just what I meant to say. I was, I am, against communism, against the Church.

ÉROUART: Anarchist . . .?

RIOPELLE: I've never been an anarchist in my heart . . .

ÉROUART: Going back to painting . . . While you were still a painter without much money, you were moved to exchange, through the good offices of a dealer, some of your paintings in order to acquire some canvases by the painter Charchoune. It would seem that this was the only time in your life that you made such a gesture. Why Charchoune, a painter who is somewhat forgotten today — quite unfairly, it's true.

RIOPELLE: It was the only way for me to acquire Charchounes. At the time, his paintings were in a very small gallery. He was unknown, except among Paris Russians . . . Charchoune was as good as any other painter, Matisse included. An immense talent . . . And Matisse would have agreed with me. If Charchoune

did not achieve the fame he deserved, it's because he was already too old. It was too late in every way — for dealers, speculators, fame: it was too late for him. Today, you can perhaps find him in encyclopedias, but barely. Take a look in the encyclopedia next to you there, just to see.

ÉROUART: He's there. But barely, as you say. There's no reproduction, illustration, artist photo. A few lines, that's all.

RIOPELLE: No reproduction? That proves he was a good painter! A reproduction is a reference. Charchoune doesn't need a reference. He never did. Great artists don't need a label, cataloguing, benchmarks.

ÉROUART: Your mother . . . you told me that after your statements to the Montreal newspapers, she threw you out because you didn't even have the courage to be a "communist." You left, slamming the door behind you. Was that a final rupture?

RIOPELLE: Rupture? That had been final long before . . .

ÉROUART: There's a part of your work that is hard to classify: the assemblages of the 1960s. They've been compared to Matisse's *Jazz* series; they've been called Riopelle's "Matisse period." Matisse was seventy-five years old, but in those works he seemed younger than ever.

RIOPELLE: That's probably a fair analysis. He influenced many others, besides me. But if I did cutouts like Matisse, shaping with scissors, it's mainly because I found it hard to get hold of all the paint I wanted. Collage costs less than tubes of paint.

ÉROUART: Your surge of youth today . . . the freshness of the colours in your most recent paintings . . .

RIOPELLE: I have no choice: I have no other colours at my disposal. Those that I use are "fresh," as you say. It's true, I'm not unhappy with the result. You have to be proud of what you do, otherwise . . .

ÉROUART: God again, the gods . . . Your relationship with God . . .

RIOPELLE: It's better not to talk about it, unless you want to justify it (which would still be to talk about it). You'd have to embark on an analysis of myths, myths as guideposts in one's life . . . No, I'd rather not talk about God. The problem as such doesn't interest me.

ÉROUART: The Riopelle foundation . . . the Province of Quebec disappointed you when it didn't come through with it. Is it too late for Quebec? If the authorities were suddenly to change their minds, would you agree to its founding here?

RIOPELLE: My idea for the foundation was to give others the possibility to express themselves. I don't believe in those who want to keep people from expressing themselves. But after all, it's my own fault if I thought I might be helpful . . .

ÉROUART: Quebec and its current problems . . . the First Nations, the demands of the Indians . . .

RIOPELLE: What sort of future can we hope for when we can't even deal with things as they are? What would we do without Indians?

ÉROUART: The recent declaration of Max Gros-Louis, chief of the Huron Nation, on television: "We, the Indians of Quebec, are still suffering from genocide at the hands of the White Man." What are we to think?

RIOPELLE: It's he who caused the genocide. The

genocide is him. He's responsible for the genocide —
the genocide of his own people.

ÉROUART: Mixed blood[1] . . . Would painting in the
twentieth century, your painting in particular, have
been the same without cross-fertilization?

RIOPELLE: There was no mixed blood. The only
gangster I know is Jacques Cartier. He was really a
gangster. The first person to kill a white man on the
American continent was Champlain.

ÉROUART: But you can't deny the existence of such
influences in art?

RIOPELLE: The best marksman of all time was a little
Indian friend of mine: he could kill a swallow with a
slingshot. Just a pebble: he never missed. I never knew
a single hunter, however good, who hit the mark
every time. The best was the little Indian from near
Montreal: with my gun I would miss from time to
time, with his slingshot he missed nothing . . . There
is knowledge that can't be passed on. There's no real
transference . . . It's impossible. I don't believe in it.

ÉROUART: You believe in "first signs," you believe
that people are born with certain gifts,[2] but you don't
believe the knowledge can be transmitted.

RIOPELLE: First signs, yes, but they belong entirely to
the creator. What comes first, yes; what comes after, no.

ÉROUART: There are counterfeit Riopelles in circula-
tion. What do you think about that? Do you admire
their technical expertise? And the act itself, what does
it mean to try and "imitate" another artist?

RIOPELLE: I think these people are wasting their
time. If they make money doing that, that's all that
counts . . . All the fakes are imitations of my paintings

from the fifties . . . I don't own very many from that period. Thirty or so at the most. Maybe I should buy some fake Riopelles to fill the gap. Or do like Picasso, who didn't buy fakes, but painted them . . .

ÉROUART: They say that Riopelle, in painting, was freedom, compared to Mondrian, who represented the mentality of the system . . .

RIOPELLE: The most beautiful Mondrians are his flowers. The mentality of the system? It's true, he wrote texts to talk about his painting. I never felt that need.

ÉROUART: Riopelle, a painter of the School of Paris?

RIOPELLE: Painter of a "school"? No.

ÉROUART: Who has talked best about your painting? Riopelle himself?

RIOPELLE: No, certainly not me. Some people said very important things about me and my work. Pierre Schneider, Duthuit . . . And others, too, who may have said things that were much less pertinent, less true, but interesting nevertheless. And still others, who only spouted nonsense.

ÉROUART: Last question: Who have we forgotten to talk about? The Quebec poet Nelligan, the Quebec singer La Bolduc, Canon Kir, whom you met one day by chance and who impressed you with his enthusiasm, your friend Gilles Vigneault, the writer Georges Bataille? Picasso? Juan Gris? A certain Serpan, a forgotten painter today, to whose memory you dedicated an important painting? Who else? Your racing-driver friends, some of whom died tragically? Schlesser, Depailler?

RIOPELLE: Nelligan always fascinated me: he spent the greater part of his life in an asylum. The most

interesting people are in asylums. I guess we could have talked more about Antonin Artaud.

Picasso? No, he's a mass of references. A reference himself. Artaud yes, Picasso no.

ÉROUART: Has everything been said?

RIOPELLE: Has nothing been said?

[1] The term used here is "*métissage*," which can mean, literally, "mixed blood," or metaphorically, "diverse influences." Riopelle, initially, chooses to interpret the term literally. (Translator's note.)

[2] The allusion here is to "Signes premiers," or "First Signs," an exhibition organized by Gilbert Érouart that included work by Riopelle and the artists Kijno and Chu Teh-Chun. Its first home, during the spring and summer of 1994, was the Palais Montcalm in Quebec City. (Translator's note.)

IV
FERNAND SEGUIN MEETS JEAN-PAUL RIOPELLE

The text that follows is the transcription of an interview with Jean-Paul Riopelle, conducted by Fernand Seguin on October 28, 1968, for the Radio-Canada television program *Le sel de la semaine*.

To transcribe a televised conversation is not easy. Hesitations, improvisations, and ellipses present no problems to a viewer when image, body language, and the spoken voice are present, but they can make a written text seem incoherent. To adapt one medium to the other means making certain adjustments — deletions, corrections, some linkages and transitions — not to alter the meaning, but simply to aid in comprehension. Whenever understanding has been well served by a literal transcription of the exchanges,

we have left them intact, even if the norms of the written word have not been adhered to. On the other hand, where clarity of thought seemed compromised by a strict replication of the dialogue, we have done some minor retouching.

Thanks go to Mme. Fernande Seguin and Société Radio-Canada for permission to publish this interview.

~

FERNAND SEGUIN: We only have to pick up the *Petit Larousse* to know that Jean-Paul Riopelle exists and that he is a painter. But the dictionary has aged him twenty years, for he was born in Montreal not in 1903, but in 1923. Forty-five years old, Riopelle is truly an international painter, one of the ten most important names in contemporary painting, which also means he is one of the ten living painters most sought after. Most of the great museums have acquired his canvases, all international exhibitions worth their salt include his work. In short, he is so famous that people forget he is French Canadian. You are French Canadian . . .

JEAN-PAUL RIOPELLE: . . . Liberal Catholic . . .

SEGUIN: It's all right, I don't need all the details . . . Pure-blood French Canadian.

RIOPELLE: Pure-blood, yes, I'm a kid from Sainte-Marie . . .

SEGUIN: Like Camillien Houde . . .

RIOPELLE: Like Camillien Houde, and . . . what's his name . . . the conductor . . . Pelletier.

SEGUIN: Wilfrid Pelletier, yes. Does he come from the same neighbourhood? Perhaps *he* was born in 1903 . . .

RIOPELLE: Perhaps. The *Larousse* says 1903, and I

should get it corrected, but there's a problem: if they correct it, they might leave me out!

SEGUIN: No, if you were dead you might have a photograph next to your name, like Rimbaud . . . Since you requested that this interview take place without a studio audience, I'm going to punish you by asking you to reveal things you might not have talked about if there were people present.

RIOPELLE: I was afraid I'd be contradicted . . .

SEGUIN: Contradicted?

RIOPELLE: If I said things they didn't agree with . . . [laughs].

SEGUIN: Oh, so that's it! Or maybe you're shy, I could understand that, you seem to be a very shy man. But you still have to confide in me. So, you're pure-blood French Canadian, from Sainte-Marie. Why do you live in France rather than in Montreal?

RIOPELLE: It's the way things worked out. France is where I've chosen to live. I may come back to Montreal . . .

SEGUIN: So it's not definitive.

RIOPELLE: Nothing is definitive.

SEGUIN: So why, now — this is a different question — why live in Paris rather than New York?

RIOPELLE: It's a question of language, first of all. That's very important. I'd have had trouble getting established in New York, even though I've spent quite a bit of time there . . . But my contacts with Parisians were easier. Because my relationships with people are never based on, how shall I say, abstract connections. I don't spend time only with artists. I prefer people I meet in the street. The storekeeper on the corner can be my best friend. And when he accepts me, then,

the average Frenchman . . . there are other kinds of Frenchmen that come along afterwards, but I need contact with the street . . .

SEGUIN: But for an artist such as yourself who is much in demand, is it not generally agreed that the centre of modern painting is now New York rather than Paris?

RIOPELLE: I don't think so. And I don't think there is a centre for painting. There are places where painters meet each other. If we consider French painting, and we say that it's Paris, we still have to admit that not all the people doing this painting are French. Far from it. The cubist school was not particularly French. It's just that they all found themselves in Paris, maybe because Montparnasse was there, or something of the sort, and they liked it. But I don't think it's just that. As for New York, what happened in New York was perhaps American painting defending itself against the avalanche of French painting at the time. Dealers were showing mainly French painting. Funny thing, for the most part they only showed the bad painting. So I don't see why . . .

SEGUIN: Are you living in Paris or outside Paris?

RIOPELLE: I'm more often in Paris than outside Paris, but with time . . . My studio is in the suburbs.

SEGUIN: Where exactly?

RIOPELLE: At Vanves. Vanves is . . . about a mile . . . which means you can't say it's Paris exactly, it's more in the suburbs. But when I need to go to Paris, to buy supplies or meet people, I never go on the Right Bank, because I buy my material in Montparnasse. Which means I'm much closer to Montparnasse than people who live in Belleville or Neuilly, for example.

SEGUIN: You have your studio at Vanves . . .

RIOPELLE: Yes, that's where I paint . . . or at least where I go, as often as I can, to try to paint. I open the door, and sometimes I just run away. I go somewhere else. I also have a foundry that I've partly transformed into a studio. All in the same general area.

SEGUIN: The foundry is obviously for your sculpture, which you've been doing since . . . 1960?

RIOPELLE: Yes, about that. I did a lot at one point, but it caused me certain problems. I wanted to work bigger and bigger. And when you reach a certain scale, to pay for the casting . . . it's impossible unless you've sold in advance!

SEGUIN: You also do engraving and lithography. Is it true you share a studio with Miró?

RIOPELLE: I'd never done engraving or litho before. And because of this catalogue, *Derrière le miroir* [*Behind the Mirror*], that my friend Calder calls "*Derrière le tiroir*" [*Behind the Drawer*] . . . It was done at a print shop, where there was an engraving workshop and a lithography workshop, behind Montparnasse, at Denfert-Rochereau. So we share . . . Miró has a studio — it's really a studio for the artists of the Galerie Maeght, and Miró uses it more often than anyone else. And since Miró lives in Spain, when he's not there, I use it. And since I very much wanted to do engraving and lithography, I've more or less taken it over . . .

SEGUIN: So you don't work together: when you leave he arrives, or the other way round . . .

RIOPELLE: Well, Miró is a workhorse — I've never seen anyone with so much energy . . .

SEGUIN: And he's seventy-five years old . . .

RIOPELLE: And for seventy-five . . . I tip my hat to

him. I like to work in the morning. I get in with the workers, I love that, to get things rolling. And he usually arrives about ten o'clock, just as I'm leaving. So he thinks I've been at work since the night before. And he says to everybody, "It's strange, Riopelle's such a hard worker!" But he's the one that does the most work . . .

SEGUIN: You said earlier that, even though you live in Paris, you consider yourself a kid from Sainte-Marie, that you might return. So you come from around De Lorimier, where you were born in 1923. You're forty-five years old. Do you sometimes look back on the child you were? What sort of child were you?

RIOPELLE: I don't know, you'll have to ask people who knew me at the time. Because my own memories are vague. I was probably like all the kids in the neighbourhood, maybe a bit more reserved — I was an only child — but it's pretty vague. I remember details. There was nothing out of the ordinary, in fact. Thrown out of school on occasion, things like that.

SEGUIN: That's the banal side. Did you get into fights?

RIOPELLE: Often enough. But I was pretty puny, unlike now . . .

SEGUIN: Yes, you were puny?

RIOPELLE: So the fights came to this: I started them and the others fought . . .

SEGUIN: Or you chose opponents that were skinnier than yourself.

RIOPELLE: Yes, well, not that I was all that afraid of the others.

SEGUIN: What did your father do?

RIOPELLE: I think he was . . . he worked on his own property . . .

SEGUIN: In the official biographies they say he was an architect.

RIOPELLE: I think at the time he was dealing with architecture, he was building. He probably came out of the Monument national and the Monument national didn't, as far as I know, really produce architects. He specialized in staircases, things like that.

SEGUIN: Was he more of a draftsman?

RIOPELLE: I don't really know if at the time the profession of architect existed . . . it was a long time ago.

SEGUIN: And how old were you when you experienced or discovered painting?

RIOPELLE: Very young . . .

SEGUIN: What do you mean by very young?

RIOPELLE: My father, of course, loved to draw. In my very first scribblers at school, the apple I drew was often guided in part by the line my father traced. In general I got pretty good marks in drawing . . . compared to other things.

SEGUIN: Of course that doesn't prove anything, because a while ago I saw some drawings of Borduas's from when he was in school. He had very bad marks, four out of twenty, or something like that. But you had good marks.

RIOPELLE: Relatively speaking. My marks in other things were so bad . . . After that, I had a M. Bisson for my teacher, he taught drawing in the schools . . .

SEGUIN: . . . the schools of the school board . . .

RIOPELLE: He took me in hand and he was a marvellous teacher for the very good reason that he did his own painting — if it was a painting — in his corner, and let me do mine. It was wonderful because he could have totally . . . the corrections came afterwards

and . . . very free. And it was a good way to spend Saturday and Sunday in peace.

SEGUIN: But you were how old when you began to get interested in drawing and painting?

RIOPELLE: Painting was my passion and I did it more and more until I went further in school and got into the Polytechnique, where I partly let it drop.

SEGUIN: You went to the Polytechnique. Why did you go there?

RIOPELLE: Because I liked mathematics.

SEGUIN: Do you still?

RIOPELLE: Yes, but it's very hard to remember it all. Mathematics is not the problem, it's memory.

SEGUIN: There are computers . . .

RIOPELLE: Perhaps . . .

SEGUIN: Electronic brains. You also went to the École du meuble, when you got out of the Polytechnique. Did you not finish the Polytechnique?

RIOPELLE: I didn't finish the Polytechnique, I did two years. Then I went to the École du meuble.

SEGUIN: Why the École du meuble and not the École des beaux-arts?

RIOPELLE: There, again . . . At the École des beaux-arts I attended a few sessions and I was a bit disappointed, because all we did was copy statues. And as I was fairly quick and knew it, I only had to attend one session a month, and then take a test the next day in order to pass. It wasn't very real to me. I didn't want to wait all those years to finally be a painter. I'd been painting for a long time. I should say that I was an academic painter. I didn't exhibit then, but I had canvases in the *salons*, such as the spring *salon*, where I was accepted as an academic painter.

It's funny, later they accepted a different kind of painting — not different exactly, but more sophisticated.

SEGUIN: But what attracted you to the École du meuble? Borduas's personality?

RIOPELLE: No. I didn't know Borduas when I entered the École du meuble.

SEGUIN: You didn't know him?

RIOPELLE: Not at all.

SEGUIN: So what attracted you to the École du meuble?

RIOPELLE: The idea of doing decoration, things like that, it's just the way things worked out. And once I was there, contrary to what you might think, Borduas's way of looking at art rather shocked me.

SEGUIN: I see! And so your first contacts with Borduas . . .

RIOPELLE: I provoked him.

SEGUIN: And how did he react to your provocation?

RIOPELLE: That was his great virtue: instead of writing me off, he saw that my antipathy could be turned into something else. And as he was a perfect guide, I changed my attitude in less than a year. In my opinion, so-called modern painting . . . here I'm going pretty far, the impressionists, for example, were cheats.

SEGUIN: What makes you say they were cheats?

RIOPELLE: Because they didn't paint what they saw. What I wanted to do was to reproduce what was in front of me. And I took that very far. And it's one of the reasons I'd given up on the idea of doing paintings and things of that sort. Because with my former teacher, M. Bisson, when you tried to reproduce what you saw, you ended up, with an educated eye, making

things that others did not see. And there was no point in copying, because what you copied, with your eye, others couldn't see. But I still thought the impressionists were cheating.

The turning point came during the war, when a series of European exhibitions was sent to America to protect the paintings. There was an exhibition of Dutch painting, and, I think, an exhibition of French painting, at the museum on Sherbrooke Street. I loved painting, and I went to see them. And, funny thing, the Rembrandts that I knew, the Tintorettos I adored — and for the most part what I had seen up to then, they had all been reproductions and so without much sensory input, and I should say there were a lot of fakes among those I had seen as originals . . .

There, in this exhibition of Dutch painting that I must have gone to see at least fifty times, there was room after room, ending with Van Gogh. And going there, I realized that Van Gogh, whom I had seen only superficially and in reproduction, was an extension of the others. As of that day, my whole world and all my judgments were turned upside-down. And it was the same thing for French painting, I think, about that time.

SEGUIN: That was in 1942, I think.

RIOPELLE: In 1941 or 1942, something like that. And that made me feel better about not doing very much, although on weekends and every time I went on vacation I went off with my box of paints and painted.

SEGUIN: And was it through Borduas that you met the old painter of Saint-Hilaire, Ozias Leduc?

RIOPELLE: Yes, through Borduas, since he was from Saint-Hilaire, and I went to see him quite often —

I even stayed with him one winter. We had few contacts with artists, Borduas and I. We went fishing in summer, in winter we puttered around, and at that time I think Borduas wasn't even painting. A dry period, I suppose. We talked of everything and nothing, and we went to see Ozias Leduc, who was an incredible character.

SEGUIN: Leduc was a figurative painter, if we want to use such labels . . .

RIOPELLE: Yes, but that's not what interested me in him.

SEGUIN: Why were you interested in him?

RIOPELLE: Because of his personality and the charm of his paintings. He was the painter of Saint-Hilaire, he was an extraordinary man. The oak table in his studio, he himself had planted the oak . . .

SEGUIN: He wasn't in a hurry . . .

RIOPELLE: . . . and he painted the same way. He began a painting with the seasons; it was a bit strange, even confused: leaves grew, and he put in leaves; summer came, then autumn, the leaves fell, he put in snow; and finally, while the sun was setting, he put in a sunset . . . It was marvellous.

SEGUIN: He could work at a canvas like that over a whole year . . .

RIOPELLE: I imagine he worked even longer on some paintings. I know that when he had people pose, they went on posing until they couldn't take it any more, because they'd done it three hundred times, and they didn't understand . . . But that was his way . . . As he got older, I believe he was trying to understand the life around him. And it's in exploring this life, constantly in flux in things and in objects, that he grew to

be, in my opinion, one of the great painters. The others weren't after the same thing; many painters painted like the painters of their generation, or like the Group of Seven or other painters of the time, thinking in terms of how painting had evolved, as they understood it. He never lost sight of his own sensibility.

SEGUIN: Going back to Borduas, once you became his friend, did he influence you in your painting, your ideas?

RIOPELLE: Where painting is concerned, I don't think Borduas wanted to influence people. He wanted to free them, to help them find themselves. And that was one of the advantages of this group of painters — if it was a group — that there was no question of saying: we are for or against abstraction, we are in favour of geometric form or not. For us, any form was valid, as long as it moved you. Obviously we must have felt that, with certain forms, that wouldn't happen. But what interested us was to find this fulfillment, this unity, wherever we could . . . And so there couldn't be just one way of painting.

SEGUIN: You and those who made up the group at the time — I'm thinking of Gauvreau, Barbeau, Leduc, Ferron — you called yourselves automatists. What did that mean?

RIOPELLE: The word "automatist" came later . . .

SEGUIN: But when it did come, what did that mean, to be an automatist in painting?

RIOPELLE: It must have had something to do with . . . We had experimented freely in a studio, a kind of shed, where we met, Mousseau with his problems, Barbeau with his problems, and myself with a third very complex problem, which was: how to find a way

of painting and having enough money to paint. And as we didn't have the money to buy much in the way of colours and brushes, we decided to paint with enamel. Now obviously there's dripping and so on, and we painted together, there were no inhibitions, it was more a question of finding ourselves than trying to create masterpieces. And finally there was a turning point, everyone probably knows about this, a clear turning point, which is what makes it interesting: Claude Gauvreau came by, and he was able to figure out who did which painting. Now you assumed it was a so-called automatic process where no one had . . . And he really sorted them out very well, chronologically in certain cases. That made for other problems, at that point. We separated and each went his own way.

SEGUIN: Towards the end of that period, when you were coming to understand where each of you was heading, there was an important manifesto, the *Refus global*. We know, historically, that it was important, it created quite a fuss at the time. You signed it along with the others, and it was written I think by Borduas . . .

RIOPELLE: The manifesto was written by Borduas.

SEGUIN: And this *"refus global"* was, as its title indicates, a universal protest. The word "protest" is very fashionable today, and we seem to think it was only invented yesterday or last month. In 1948, what were you protesting?

RIOPELLE: I haven't read it in a long time, but I think the idea was to refuse those conditions, both material and intellectual, that had been our lot up to that point. That's what the refusal is all about: to reject those conditions laid down by society at that time, whereby each person went home and did the best he could on

his own, in a fixed world that had Borduas continuing to teach at the École du meuble without making any waves so as not to annoy the people around him and above all not to upset the art schools . . . Because the École du meuble was not really there to produce artists, painters . . . But it turned out that practically everyone came out of the École du meuble, which was a bit embarrassing for all the others . . . And each person was supposed to keep to his place in society, whatever it was, and that was something we refused on principle.

SEGUIN: The *Refus global* was, in other words, a cry for freedom in the face of all the constraints society imposed on you.

RIOPELLE: The thing is, there was a historical side to the whole affair. We have to talk about surrealism at that time, which for us was brand new because publications reached us late, and with difficulty, from New York. It's from there that surrealism and painting found their way to us. And we saw that we had something in common with that. And so, when I left for France, I contacted the surrealists of the time, including Breton.

There was then a French manifesto, called *La cause est entendu* [*The Cause Is Heard*], which attacked the *revolutionary* surrealists, who were against surrealism as such and wanted to tilt it towards the communists. Some Party intellectuals wanted to bring the surrealists in. This manifesto was not written by Breton, as everyone thinks, but by a friend of mine, Pastoureau. And Pastoureau gave it to me to read — because he saw my problems in Canada — and we talked things over. I sent this manifesto — or I brought it myself to

Canada — and we considered adding our own names to it. I was against that, for the very good reason that I thought it was better to have something that was valid locally.

SEGUIN: That came from here, and dealt with the problems here . . .

RIOPELLE: . . . because to add our names to those of the surrealists who had signed in France didn't make much sense to me (it was in fact an anti-Stalinist document, tending towards Breton's position, which was Trotskyist). Now you mustn't get the idea that this manifesto had a lot of impact; the surrealists never reached a large public, it was only later . . . But it seemed to my friends to be an extremely important commitment. I thought it was better to keep our distance and to make our own statement. And Borduas wrote it, with us collaborating all the same, and that went on for some months, I don't remember exactly, before it was published.

SEGUIN: Even when we read it twenty years later, we see that it was quite a violent manifesto, categorical in what it rejected, and it went very far. At the time, it was treated as the work of a small band of hotheads. But it still had an impact. The most immediate consequence was Borduas's losing his job at the École du meuble. What were the consequences for you? And is there any link between that and your departure for Paris?

RIOPELLE: No, because I was already in Paris, and unfortunately I had come back without a return ticket in my pocket. And as I had no money, I had to find a way to earn some before leaving again. Because I would have returned to Paris earlier, even if it meant another trip back here. I've always gone back and

forth willingly, but I like my return to be guaranteed. The manifesto was not a reason for my leaving.

SEGUIN: You went to Paris the first time in 1946.

RIOPELLE: In '46, yes.

SEGUIN: The *Refus global* dates from '48, and you had come back to Montreal. You said you had no money. But when you want to paint and when you set yourself up, whether in Paris or Montreal, there are some immediate problems: you need to find a studio, you need to buy tubes of paint while waiting to be discovered, while waiting to sell your work. Were those difficult years for you?

RIOPELLE: No. Because the joy of working, of being free, was compensation. And it compensated, probably, because my needs were less great. You understand, I found myself in Paris, unable to afford a car, and it made no difference to me whatsoever. If your living conditions were difficult, if you froze in winter because you couldn't pay for heating, there were other things that made up for it. And then, of course, I'd had to deal with other problems, why not that? And Paris, France, in general, seemed to me quite . . . what I felt wasn't rational. I never thought, when I arrived the first time with the horses, and saw Rouen, which was a city that had been completely destroyed . . . when I entered it, I said to myself, it's very good here, I like it. And I didn't even see what was good about it. I saw that the Seine valley was superb, and I saw a way of approaching things that appealed to me . . . I never thought any differently.

Most French Canadians who go to Paris are there as students. And I think that for them, the first year is always hard. And with their first winter, they realize

that it's colder, relatively, there than here, because the old buildings . . . And so they leave France after the first year, quite disappointed. And I think it's a mistake for them not to stay longer, for the good reason that — and I'm saying this because I want to help those who have study grants, and things like that — when you give a one-year grant to an art student so he can go to Europe, before he can see all the museums, which is difficult because often the grant isn't enough, it takes the whole year, between Spain, Italy, France, and other places he wants to visit. What do you expect . . . first there's the problem of a studio, and after one year he has to come back . . . it's absurd . . .

SEGUIN: You think we're kidding ourselves, giving grants to painters . . .

RIOPELLE: It's very good that they've gone to Europe, it's good that they've seen it, but to think that those who return will have gone beyond a rudimentary view of what is there . . . We must give them other grants, because a year is nothing.

SEGUIN: Have you ever had a grant?

RIOPELLE: No, I never had a grant. I've been told that I had a grant, but I'm still waiting for it . . .

SEGUIN: I see! Today that would just about pay for your cigarettes! How many years did it take before you achieved, not necessarily success, but enough recognition that you could sell your canvases and buy paints to do more of them? Was it long? Do you remember what prompted people to begin talking about you, for instance?

RIOPELLE: Yes, but I'd have to go into all the details. It's always the details that are interesting, but I wonder if that's really true in this instance. I had got to the

point where, in fact, it was no longer a question of . . .
First, because for the most part, the people who knew
my painting and liked it, who saw its possibilities,
couldn't afford to provide me with a livelihood. For
them, it was simply a matter of helping me, and
telling me that if there were anything I needed . . .
Details. But, as you say, you need colours and you
need a lot of them, especially when you paint as I do,
and that was out of the question. Until certain dealers,
who had kept a close eye on me without ever making
a move where materials were concerned, saw that
things were going very badly . . .

I had no studio, no gallery, and I had just had a
show where I had sold nothing. Then a sculptor friend
of mine said: "I'm having an exhibition in a little-
known gallery, I like your painting, why don't you
hang some of your things?" I replied: "Why should I
show again the same canvases people have already
seen? Nobody talked about them, I didn't sell any-
thing; the dealer told me, 'I really like what you're
doing,' but he didn't buy a thing." She said, the sculp-
tor, "I like what you do, I'll pay for the catalogue, I
have a friend who'll write the preface . . ."

The day of the vernissage, a dealer walked in and
said to me: "I very much like your work." I looked at
him and I said: "Listen, you've been telling me that for
seven or eight years." "No, but I'm serious, I'll buy
everything." I said: "That's bizarre! But if that's the
way it is, so much the better." Then one of his friends
came up to me and said: "Monsieur, do you need a
studio?" I thought to myself, I don't believe this. He
said, "I'm leaving for Egypt tomorrow, come to 52 rue
Durantin, the key is there, I'll be back in six months."
I stayed three years in that studio.

SEGUIN: That's fantastic! So those were the early years. Success, as you've just described it, came in a flash. Now, you're established in Paris and elsewhere as well. I'd like you to talk a little about how you work. For example, I don't know if it's true, but I've been told that you don't like people to watch you paint.

RIOPELLE: Not only that, but I couldn't do it . . .

SEGUIN: You couldn't paint if someone were watching you?

RIOPELLE: I can't put on a show. The truth is, I don't think I even like watching myself paint, and if I realize while I'm working that I'm starting to be critical — it's afterwards that you have to be critical — then I just stop and go away. If later on I don't think a painting is good, or if it's unfinished, I usually destroy it. But that's all tied up with time. It doesn't mean that occasionally I won't take up a painting again, but then for me, in my mind, there's been no interruption. If someone's watching there's always a distraction, and it's that distraction I could never endure.

SEGUIN: It's also been said, you've talked about it just now, that for the most part you don't rework a painting, you paint it in one fell swoop.

RIOPELLE: In general, in one session.

SEGUIN: And, if I can ask a nuts and bolts question, such a session might last how long?

RIOPELLE: Well, since I've just said that I can't watch myself paint, it really is a question of time: when I've finished a painting, I don't remember when I began it. Obviously, it's a matter of hours for the most part, but I've sometimes started a painting, put on the lights, and shut them off the next morning without being aware that any time has passed.

SEGUIN: So when you paint, you're in a kind of trance . . .

RIOPELLE: I don't know, it's not for me to say. I have a friend, someone I know quite well, who is a billiards champion, and whom I go to see quite often. He's an absolute whiz at billiards. M. Conti wrote a book that began: "Whoever wants to learn to play billiards and to play it well must dream about billiards all the time." I think that's true for painting, for billiards, or for anything else.

SEGUIN: Anything one loves . . . you have to dream about it.

RIOPELLE: It's the same way for hunters. They go off hunting, and when they return, they don't return within time. They often, they almost always, come back without any game, but they're ready to go off again right away, and then night falls and they don't even notice.

SEGUIN: To go back to your painting, the way you describe what you do prompts me to ask you this: in your work we can discern different periods, Riopelle's periods. Does that correspond to something real, real for you, something deliberate, or is each painting an adventure that has nothing to do with the one before or the one after?

RIOPELLE: I always hope that the painting I'm working on is my ultimate achievement. That is, the most beautiful, the best, the definitive painting. When I'm finished, I realize that it always resembles the one that preceded it, and that it's far from definitive, so I start on another.

SEGUIN: Through all that, there's nevertheless been an evolution, if only in the thickness of the paint.

There was a period when, with your oils in particular, the entire space . . .

RIOPELLE: But the problem of thickness is a simple problem for me. I always hope that the first stroke . . . I always begin with a mass of colour, no matter where, no matter how — I can't say that I begin at the top, at the bottom, in the middle or anywhere else, or with any colour in particular — but there has to be enough of it. And I guess I don't feel there's enough, because sometimes it comes out incredibly thick. But I never wanted to paint thick. I never made thickness for the sake of thickness. Just for myself. But I never get to a point where I'm satisfied. So I add on more. When I'm a better painter, I won't paint so thick.

SEGUIN: And it will cost less . . . in paint, not in price! In modern painting, from a technical point of view, there have been a number of developments, including new materials such as acrylic paints. Where your own paintings are concerned, you remain loyal to the traditional medium, to oils.

RIOPELLE: You know, when it comes down to it, I'm considered an old academic painter. Compared to the young generation, the American school especially, the painters of my age are the old guard. There's an American term . . . "late" . . . I don't know, a ripe age . . .

SEGUIN: "Has-beens". . .

RIOPELLE: So my technique, when I paint, is, I think, quite classical, although I've departed from that a bit in the course of my work. But, for example, I never begin a painting without having ready to hand all the colours I need. I would even go so far as to say — obviously I don't use a palette, but the idea of a palette or a selection of colours that is not *mine* makes

me uncomfortable, because when I work, I can't waste my time searching for them. It has to work right away. Of course, where materials are concerned, if I use new materials, I have to experiment with them. I'm quite happy to do that, if I don't have the others; but if I have the others, I prefer to use them.

SEGUIN: You are, in this respect at least, attached to the past.

RIOPELLE: Yes. My way of looking at a painting and judging it corresponds to the way paintings created in oil on an easel have always been seen and judged; the idea of painting on canvas pleases me more than the idea of experimenting with another material, whether harder or softer; that interests me less.

SEGUIN: Talking about harder material, you have, all the same, tried media other than painting, lithography for example — you've been doing more and more in the last few years — and sculpture, too.

RIOPELLE: Litho and engraving, that contradicts to some extent what I just said about the idea of a direct line and so on, but that doesn't bother me.

SEGUIN: And sculpture? You're considered a painter who does sculpture. Do you consider yourself a painter who sculpts?

RIOPELLE: No, I don't. There are a number of people, friends of mine, who are of the opinion that my sculpture is more important than my painting. But I don't think so. There are others who think that Riopelle is a painter who does sculpture. For me, they go together. My approach to sculpture, for the moment, consists in seeking to discover or create forms. Now these forms I make from lost wax or clay, so there is a direct contact, and that's what interests me. I think one doesn't go

without the other: that my painting influences my sculpture and my sculpture influences my painting. That's my idea, maybe it's false, perhaps I'm mistaken . . .

SEGUIN: You're still primarily known as a painter. I said before that you are what one might call an international painter, which means that a canvas signed Riopelle now sells for a lot of money. There's nothing wrong with talking about that. How much does a Riopelle sell for?

RIOPELLE: I have no idea.

SEGUIN: Why not? How is it that you don't know the price of your own paintings?

RIOPELLE: It's very simple. There's a historical side to the art market, for me. There were two ways of proceeding: to deposit your paintings with a gallery and to receive a percentage of the sales . . .

SEGUIN: Which is very common in Montreal . . .

RIOPELLE: It's common in New York and Montreal. There's a very different concept in certain European galleries, where a dealer takes on a stable and buys very cheaply everything they produce. The sale price for the painter to the dealer is very low because he takes practically everything. He takes a chance on, let's say, five painters. Theoretically, you might say that in the market — this is very down to earth — a dealer with a lot of flair might succeed in establishing — and not because the painters aren't good — one painter in five, if they're painters with no reputation. Now for the most part, a dealer isn't at all interested in this kind of painter. He's waiting for someone who's made his name — at least a little. But really, if he takes on people he likes, it's usually one in five . . . if the

dealer has flair and a good reputation. Which means that the price of my paintings has always been low — because I've never sold for a percentage, I've never given my paintings on consignment, I've always found people who bought all my work (or shared it between two galleries). Now, if they give me money so I can produce — that's how I feel — the price they get is of no interest to me whatsoever.

SEGUIN: For your information, a good-sized Riopelle sold for two thousand dollars ten years ago, and now, I think, would sell for about five thousand dollars.

RIOPELLE: I hope it's a good painting . . .

SEGUIN: And that is a success, if only in material terms. I think it's the first time in Canadian painting that a Canadian painter arrives in Paris, totally unknown, and in a few years develops an international reputation.

RIOPELLE: Yes, but perhaps other Canadian painters didn't have the same opportunity.

SEGUIN: Agreed, but you, having had the opportunity, took advantage of it. You're a painter in demand, and so in principle . . .

RIOPELLE: But I don't think — and maybe it's too bad — that being Canadian had anything to do with it. Nothing at all. People have often talked about wide-open spaces, but without linking them in any particular way with Canadian conditions. And as my stays in France were never based on the idea that "Hey, I'm a Canadian," and in France I'm a sort of tourist, I've always dealt with people who said to me, my God, maybe he's from the Auvergne, when I was in the north, or maybe he's from Normandy, when I was in Châteauroux. France is a collection of villages, and

in these villages, this region, often people think that the next department over isn't really part of France. Now I was always from the other department . . .

SEGUIN: What do you do for fun when you're not painting? I understand you have a passion for automobiles . . .

RIOPELLE: I used to like automobiles a lot, I raced them . . .

SEGUIN: You raced them?

RIOPELLE: Yes, but those too are details . . . In the beginning, when I raced automobiles, you could do so and finance your own car. And as there were not many big races, and not many cars or organized teams, you did everything you could to put a pretty good motor together with a pretty good body and try your best to make something of it. Now, with all the bankrolling by the big companies — Ferrari, Ford, or Porsche — an individual, unless he's a multimillionaire, can't develop a car, not the way the others can. So as a result, the pleasure of automobile racing, even as a sideline, is out of reach for the average person . . . unless you're really one of the great drivers who can succeed, no matter what. It's like anything else. If someone is a mechanical genius, if he's in love with it, if he's one of the fifty best automobile racers in the world, he can always try his luck in Formula One. But . . . there's room for fifteen or seventeen people like that . . .

SEGUIN: The car we see on the screen looks like a car from the time of Louis XV. What is it?

RIOPELLE: No, but seriously . . . My passion for cars was also a passion for machinery. And I got to know the automobile, really, when I saw these perfect machines. Now this car, which is a Bugatti, is, from a

mechanical point of view, one of the most beautiful things that has ever been built.

SEGUIN: What year is it?

RIOPELLE: Nineteen thirty-four. But this perfect machine is dear to my heart, I'm holding on to it, and I love it. I drive it whenever I can, when the roads aren't too crowded, and the controls respond.

SEGUIN: Is it true that the motor oil is castor oil?

RIOPELLE: Yes. That too is a very technical matter. In automobiles, up to now, the oils were not very good. And you still have castor oil in cans whose labels have different models of cars on them. But you use castor oil, really, because it's an oil that doesn't lose its viscosity at high temperatures. So you can heat the motor without . . . burning out the rods! And that's why you use castor oil in this car, which has a tendency, under certain conditions, to overheat — and even if it doesn't, you can't take the chance, because to replace a motor is practically impossible . . .

SEGUIN: Is there a connection between your love for machines and your love for sailing?

RIOPELLE: One led to the other. The day I decided no longer to race automobiles, for mechanical reasons and others, I decided that . . . I had been told that to own a Bugatti would cost as much as to keep a dancer from the Opera . . .

SEGUIN: A Bugatti is more faithful, if you can get parts for it . . .

RIOPELLE: . . . so when I saw that I could no longer race, I said to myself: now I'm going to be completely crazy, and I was, completely crazy, I bought a sailboat, and I can tell you, you have to be crazy to keep one of those . . .

Seguin: Or have no liking for dancers from the Opera . . . Is that for your vacations, the sailboat?

Riopelle: Yes, well, mainly it's an obsession . . . because you have to keep it up, there are always problems with the crew, with the sails, with everything. A boat is a house that can't have any flaws. If a drawer can't be blocked, when it gets rough it falls on your head. And these dangers are really serious, because in a storm, there's no margin for error.

Seguin: And in a painting, can you make errors?

Riopelle: Well, that's for others to decide. But in a boat, you're risking your skin.

Seguin: But in painting, when you come in for criticism, aren't you also risking your skin, in a way?

Riopelle: Yes, but you can always start over, while at sea . . .

Seguin: Those who look at your paintings and like them are obviously in the majority. There are, however, certain people — I don't want to reopen here an old tired debate — but there are people who look at what you've done and say: what does that represent? And you have already said — you've often repeated it, it's almost a motto for you — you claim that nature is your only source.

Riopelle: Yes, but nobody has to see that in my work. For me, in its organization, nature is my source. But others can see what they want. In general, I think that things when they are organized are part of nature, that's what I mean by nature.

Seguin: You have a profound love of nature, of what is alive, and even that which is not alive except at the atomic level, such as rocks . . .

Riopelle: My work is a kind of response to that, if

you like. I have never yet seen a lunar landscape. So nature for me is what's alive in that season, it's the details; and that's what interests me. It's what prevents me from ever being bored when I'm out in nature. I love to hunt, I love to fish, and all of that. I also think that has a lot of influence on what I do.

SEGUIN: Yes, but not an immediate influence, cause and effect, it's more a transposition, a reshaping in your mind of what you've seen, is it not?

RIOPELLE: I think the influence is quite immediate, because I see it in the paintings that come out of such an experience, for example, if I've just made a voyage to Corsica . . . I'll tell you for sure when I get back to painting, but the plane trip from Bas-du-Fleuve to here, losing altitude all the time, with these red woods, I don't know if it will happen, but it seems to me something should come out of it — not the red, but an organization of all that. In any case, I'll let you know later!

SEGUIN: I'm afraid we wouldn't have time to deal with it anyway, we've only got a minute left . . .

RIOPELLE: No, next year . . .

SEGUIN: Ah, when you come back . . . But as this program's only got a minute left to live . . . if you had a year left to live, what would you do?

RIOPELLE: I'd try to make it longer.

SEGUIN: But if you were to paint during that year, would you go on in the same way? In other words, are you satisfied with what you've done up to now?

RIOPELLE: But I wouldn't believe I had only a year left.

SEGUIN: Too optimistic for that. Let me ask the question differently: do you have a dream, an ambition in life that you have not yet fulfilled?

RIOPELLE: What problems you make for me! One must always start over, no?

SEGUIN: Always?

RIOPELLE: Of course.

SEGUIN: Perhaps that's Riopelle's secret, this constant urge for renewal.